Hollis
Sigler's
Breast
Cancer
Journal

Hollis
Sigler's
Breast
Cancer
Journal

with texts by

SUSAN M. LOVE, M.D.

and JAMES YOOD

HUDSON
HILLS PRESS,
NEW YORK

This book is dedicated to Patricia Locke, with love.

FIRST EDITION

© 1999 by Hollis Sigler

All rights reserved under International and
Pan-American Copyright Conventions.

The Last Thing on My Mind, by Tom Paxton © 1964 (Renewed)
United Artists Music Co., Inc.
All Rights Controlled and Administered by EMI U Catalog Inc.
All Rights Reserved Used by Permission
Warner Bros. Publications U.S. Inc., Miami, FL 33014

Published in the United States by Hudson Hills Press, Inc.,
122 East 25th Street, 5th Floor, New York, NY 10010-2936.

Distributed in the United States, its territories and possessions, and
Canada by National Book Network.

Distributed in the United Kingdom, Eire, and Europe by
Art Books International Ltd.

EDITOR AND PUBLISHER: Paul Anbinder

MANUSCRIPT EDITOR: Virginia Wageman

PROOFREADER: Lydia Edwards

DESIGNER: Betty Binns

COMPOSITION: Angela Taormina

Manufactured in Japan by Dai Nippon

The publisher gratefully acknowledges the assistance of the
National Museum of Women in the Arts, Washington, D.C.

All photographs are by Michael Tropea, with the exception
of numbers 22 and 23, which are by Jacques Gael Cassidy.
The photograph of Hollis Sigler is by Jean Hilary.

Library of Congress Cataloguing-in-Publication Data
Sigler, Hollis, 1948–
 Hollis Sigler's breast cancer journal / Hollis Sigler ; with essays
by Susan M. Love and James Yood. — 1st ed.
 p. cm.
 Includes bibliographical references.
 ISBN: 1-55595-175-9 (cl. : alk. paper).
 1. Sigler, Hollis, 1948– . 2. Breast cancer patients as artists—
United States. I. Love, Susan M. II. Yood, James. III. Title.
IV. Title: Breast cancer journal.
N6537.S539A4 1999
759.13—dc21 99-32014
 CIP

CONTENTS

Acknowledgments 7

Foreword BY SUSAN M. LOVE, M.D. 9

Hollis Sigler: An Appreciation BY JAMES YOOD 13

To Kiss the Spirits: My Breast Cancer Journal
BY HOLLIS SIGLER 19

COLORPLATES 35

References 95

ACKNOWLEDGMENTS

BY HOLLIS SIGLER

This book actually began in 1993 with the publication by Rockford College of the catalogue for *The Breast Cancer Journal: Walking with the Ghosts of My Grandmothers.* The interest in that catalogue got me thinking about the possibilities of doing a book on my breast cancer series. My thanks to Maureen Gustafson and the personnel of the Women's Health Advantage of Rockford Memorial Hospital for their work on the catalogue. And for his dedication to bringing this idea to reality, I wish to thank my assistant of fourteen years, Joseph Howard.

Then there are the people who helped to keep me going physically, most especially my oncologist, Dr. Janet Wolter. One of the first "cancer doctors," as they were known, in the Chicago area, she herself was diagnosed with breast cancer in 1983. I am grateful not only for her experience but for her level-headed and compassionate approach. Along with Dr. Wolter, the nurses in the treatment section of Rush Presbyterian St. Luke's Hospital get my deep appreciation for their kindness and optimism.

There are more people who helped put this work in the public eye. Ruby Rich, a dear friend, critic, and author, wrote an article about my work for *Mirabella* magazine, the response to which was wonderful. Beverly Dector, director of Marin General Hospital's Humanities Program, worked with Susan Cummins of the Susan Cummins Gallery in Mill Valley, California, to make the first showing of the *Breast Cancer Journal* a success. And I am of course grateful to Susan

for taking the risk of showing the art in the first place. I wish to thank my other dealers for their tireless efforts to promote work on a difficult subject: in Chicago, Robert Hiebert and Sidney Block of Printworks Gallery, and Carl Hammer of the Carl Hammer Gallery; in Baltimore, Steven Scott of the Steven Scott Gallery; and in Kansas City, Missouri, Sherry Leedy of the Leedy-Voulkos Art Center Gallery.

Probably the biggest boost given to this series came from the National Museum of Women in the Arts in Washington, D.C., where a one-person exhibition of my journal was held in 1993. To all those involved, especially Susan Sterling, curator of modern and contemporary art, I offer my sincerest gratitude.

Special thanks go as well to Lynn Kable and the Society for the Arts in Healthcare and to the Polaroid Corporation for their cooperation (along with the National Museum of Women in the Arts) in creating the national tour of replicas of my *Breast Cancer Journal*.

Others I wish to thank are Bob Schroeder of the Fort Wayne Museum of Art and Colleen Benninghoff, breast cancer survivor and community activist from that area; Stacey Boris, curator at the Museum of Contemporary Art in Chicago; and Virginia Smiley, author and teacher, who volunteered to look over my manuscript.

Finally, I wish to thank my two co-authors, Dr. Susan Love and James Yood, for taking time out from their busy schedules to amplify on the work shown here.

FOREWORD

BY SUSAN M. LOVE, M.D.

As I sit down to write an introduction to this remarkable collection of art, I am overwhelmed by thoughts of the many women I know who have been touched by breast cancer. Over the past decade we have increased the dialogue about this disease, such that public service announcements remind us to get a mammogram and photographs of one-breasted women stare back at us from the cover of the *New York Times* Sunday magazine. What we hear less about is how it feels to have breast cancer, most especially, how it feels to have breast cancer that has recurred. Almost all of the books, television shows, and magazine stories about breast cancer depict the woman who is newly diagnosed. She faces breast cancer squarely, and after undergoing surgery, radiation, and chemotherapy she wins her battle. Society's message is relentlessly upbeat. Early detection saves lives. Aggressive treatment is the best hope. There is almost nothing said about the woman in whom breast cancer comes back. There is still shame attached to recurrence—as if the woman or her doctors have failed in some way. Either she did not "catch" it early enough because of her own negligence in getting mammograms or doing breast self-examination, or she did not treat it aggressively enough. The secret used to be that women got breast cancer. Now the secret is that many still die from it, through no fault of their own. By describing both her own and her mother's experience, Hollis Sigler gives a voice to the woman struggling with the reality of breast cancer—not the ever-happy face the public wants to see, but the real face

of a woman living with a chronic and potentially life-threatening disease. It is this reality that makes her art so difficult for many women to face, and it is this reality that also makes it so powerful.

What is behind the sound bites about breast cancer? What is the reality of this disease? Unfortunately we have made little progress from the time that Hollis's great-grandmother died of breast cancer. We would like to think that early detection is the answer, and it is . . . for some women. But most breast cancers are present for eight to ten years by the time they can be felt or seen on a mammogram. The breast cancer cells have the ability to get out of the breast into the blood vessels very early, at about year one or two. From there they can spread throughout the body, and they do. Whether they persist depends on their ability to survive in another organ as well as on the immune system's ability to destroy them. Studies have shown that regular screening mammography can find cancer at a curable stage in 30 percent of women over the age of fifty. That is a lot. It is the fuel for the push for availability of screening mammography. But it is only 30 percent, not 100 percent. That is because some cancers are so slow growing that they will never spread. Others are so fast growing that they have spread by the time we have found them. Many women will have their cancers detected by mammography and still die of the disease. Breast self-exam is even less successful at making a difference in breast cancer survival. Most women find their own cancers but not necessarily at a curable stage. This is not because they are lax about their technique of breast self-exam but rather because they are not very lucky. By the time they can feel a lump the cancer has already spread.

What about the newly discovered genes for breast cancer? We have identified two of the genes that are mutated in women with hereditary breast cancer. But only 10 percent of women with breast cancer have hereditary disease. And even if we were to test all of these women and their families, what would we do about it? We have no proven method for prevention, nor do we have proven methods to protect women from discrimination based on their errant genes. More important, most women with breast cancer have no risk factors for the disease.

Surely we have made progress in treatment? Yes and no. We have realized that breast conservation is as good as mastectomy in preventing breast cancer from coming back in the breast. But what kills women is not the breast cancer cells in the breast, but rather those that are already ensconced in other organs of the body. Whether the breast is removed or kept, those cells are already there, lying in wait for the opportune moment to spring to life again. With chemotherapy and Tamoxifen we have been able to alter the mortality of breast cancer a bit. But an absolute 5 to 10 percent improvement in survival is not a

cure. Even high-dose chemotherapy with stem cell rescue (bone marrow transplant) has yet to be proven the answer to this insidious disease. One-third of the women who are diagnosed with breast cancer will die of it despite the best we have to offer them.

What is the answer then? I think we need a completely new paradigm to attack this problem. We have gotten about as much as we can from slash, burn, and poison. We need to focus on prevention and control. Our previous view of breast cancer was based on the notion of a foreign invader, not unlike bacteria, which had to be completely eradicated...hunted into extinction. But a new view of cancer and particularly breast cancer is gaining attention among scientists. The cancer cells are not a foreign invader but rather normal breast cells that have gone awry. And just as in a mental health analogy, maybe we can change their environment and rehabilitate them. It is amazing to me that for all these years we have been studying breast cancer cells in isolation...alone in a test tube or petri dish. We have only recently come to recognize that this is like describing someone's personality while keeping them in an isolation chamber. People's personalities are formed and reflected in the many interactions they have daily with everyone with whom they come into contact. Similarly, the surrounding cells and tissues inform the breast cancer cell's behavior. The cure may not be in killing cancer cells but rather in controlling them.

This new paradigm looks on cancer as a regulatory problem, one we should be able to fix by altering the regulation of the cells. It calls for a whole new approach to treatment. It starts to explain the occasional successes of treatments that change the systemic environment, such as nutrition, meditation, Tamoxifen, or removal of the ovaries. It begs us to find other even more successful means to keep these cells under control. And it offers hope to the many women who are on this journey. This approach to breast cancer is not science fiction; it is the basis for much of the current laboratory work on this disease. Treatments are currently being tested that are based on this hypothesis. I predict that within the next ten years we will see a revolution in the way we approach this disease. And it is about time. Breast cancer has been around for too long. Now is the time for all of us to stand with Hollis Sigler and all of the women living with this disease and say "enough." Hollis was there when the National Breast Cancer Coalition started its petition drive, and she was there when we handed the petitions to President Bill Clinton at the White House. We must all keep up the pressure for money and research so that she will be there when we find the answer to this disease.

Pacific Palisades, California

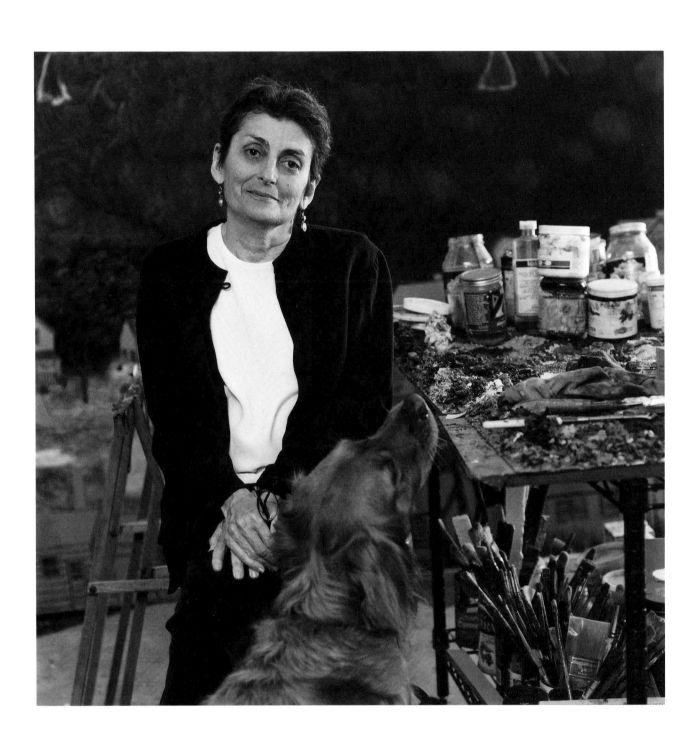

HOLLIS SIGLER

AN APPRECIATION

BY JAMES YOOD

Hollis Sigler is not an artist because she has breast cancer; Hollis Sigler is an artist with breast cancer. She brings to her current challenge, to all its moments of despair, revelation, poignancy, sorrow, exhilaration, agony, hope, dejection, frustration, and tenderness, precisely the same extraordinary pictorial skills and intuitive sensitivities that have made her for two decades an artist with remarkably tender and nuanced considerations of the muddied passages of the human heart. Despite the fact that people practically never appear in her work, Hollis Sigler is a humanist in the finest sense of the word, and her images plumb the incredible panoply of emotions and comprehensions that can comprise the human comedy. Sigler's *Breast Cancer Journal* does many things, but above all else it both touches and teaches—it reminds us that while breast cancer is clinically a medical condition, it will always be manifested as a profound part of the life journey of the individuals who carry it within them. In recent years Sigler's art has played a significant role in unmasking breast cancer's fearsome anonymity, giving it and the struggle of those who live with it a decidedly personal profile, a step-by-step account of battles won and lost, and of achievements particularly dearly realized.

Hollis Sigler's circuitous path toward this body of work is a surprising story of its own. She was educated at the Moore College of Art in Philadelphia and at the School of the Art Institute of Chicago, and she has lived in the Chicago area since the early 1970s. Her early

work reflects a scrupulous and highly skilled realist painter, and her very large canvases of the mid-1970s were well versed with much of that moment's art taste; Sigler's cool, impersonal paintings demonstrated her intense study and bravura photorealist skills in curiously chilly and anonymous images that remained distant and aloof. This, Sigler soon decided, would not do. In a remarkable act of artistic refocusing and reinvention, she literally retrained herself, starting with a series of crayon drawings in 1976. She dismissed her consummate realist skills, sensing that the lack of emotional engagement in her large canvases reflected a strategy of existential distance and noncommitment. Sigler chose instead an approach so visceral and generous, so immediate and uncensored, as to provide her an entry into previously largely untapped resources of feeling and emotion. Her shift in thinking and making seemed to be almost an unlearning and an unburdening, an effort to cleanse herself from coded stylistic strategies in order to pursue something that might open up possibilities that were more natural, organic, and honest. Some predecessors Sigler particularly admired, especially Florine Stettheimer, and Chicago's own historical openness as an art scene, as a place where highly personal and idiosyncratic visions have long been nurtured, provided Sigler with models and the freedom to leave the "isms" of modern art behind. She moved toward breaking the art rules as necessary to liberate her intelligence, exploring her desire to infuse this new work with content and intensity.

Critics and curators have tried at times to describe in words the peculiar attractions of Hollis Sigler's pictorial style, and I have been guilty myself of employing the term "faux naïf" as a terse way of analyzing her open and fresh manner of creating imagery. (Sigler's work can be called many things, but it is neither "false" nor "naive".) A painting or a work on paper by Sigler presents a lot of things to think about, and it always does so in a pictorial language that is straightforward and extremely accessible to its viewers. We immerse ourselves in her constructed world, suddenly becoming voyeurs peeking into pungent slices of life, into sites made tense and ready for drama. Everything is animated by her short and cursive brushstroke, everything unified by a similarly spiky and nervous quality, everything heightened by its transcription into intense and often bright colors. Sigler prefers balanced and symmetrically framed compositions, and she usually arranges her elements parallel to the picture plane. There is nothing one cannot identify in her work, no arcane art lingo, nothing that is not drawn from the readily available vernacular of middle-class life.

Sigler depicts places momentarily abandoned by human figures but still seething and reverberating with the emotional temperature of their presence. She creates a world where imagination reigns, where

freedom seems at home, a place tweaked and stimulated just enough to provide the settings that can analyze the range of intimate vignettes comprising contemporary bourgeois existence. Sigler opens up to the bittersweet vagaries of the human drama, and she is a disarmingly sensitive observer of the poetic nuances everywhere dormant within domestic spheres. In work after work she explores what it means to love, to enjoy small pleasures, to consider both the wonder and the ambiguities of human relationships, and to inventory the thousand tender wounds of intimacy. Her work is verdant with the promise of evenings spent with friends, with the potential for joy resting dormant within a summer's evening, as well as with tracing the awkward vulnerabilities inherent in any sexual union, and with rampant fantasies of victory and liberation, all comprising the foibles and tendernesses that in their aggregate chronicle the fundamental wistfulness of the American dream. Sigler's images, with their titles often scrawled across them, constitute a corpus of work revealing the possibilities for a genre painting of the human spirit at the end of the twentieth century.

And then in 1985 came her cancer. Her essay elsewhere in these pages speaks eloquently of the human struggle presented to her by the onset of her cancer, and initially that was much more a private than a public concern. Sigler's art between 1985 and 1991 almost never directly deals with her cancer. It is there, hovering a bit in the background, just an indistinct shadow, much as it would appear on an x-ray. Sigler was in those years getting on with her life, hoping along with her doctors that she would be among those who had experienced a sobering confrontation with cancer, one that for the most part was resolved. In the years leading up to 1991 her work is undoubtedly more chastened, more inclined to consider the preciousness that exists within life than to fantasize on the promises to come. Sigler was subtly altered, and the gloomier aspects of her experiences with breast cancer only heightened the elation and amazement she felt about the continual power of love and life. But one could experience her work during those years without suspecting that Sigler had confronted cancer; like many women in her situation, she felt isolated and kept her privacy intact.

The subsequent recurrences of cancer in Sigler's body, its cruel metastasizing into her bones in 1991, and her clear realization that she would struggle in one way or another with cancer all the rest of her days began the processes that have led to her *Breast Cancer Journal.* Hollis Sigler got angry, and then she got busy. Her frustrations with the confusing and meager flow of sometimes contradictory clinical information, with the lack of outreach resources, with the sense of being isolated with a potentially terminal disease while simultaneously certain that everywhere there were thousands, no, millions, of

women in precisely her position spurred Sigler toward the activism of the *Breast Cancer Journal*. She confronted a widespread epidemic wrapped in impermeable silence, knowing that those who suffered and died in its wake often did so with no voice, unarticulated and unvisualized.

Sigler had come of intellectual and artistic age in the 1970s, and she well remembered and understood those aspects of feminism that led to publications such as *Our Bodies, Our Selves.* She knew that women, one by one, often beginning in isolation, had created new networks of communication to provide exchanges of information that would directly address critical issues in women's lives, that would combat those structures, intended or unintended, that had hitherto frustrated women's efforts to inform themselves more fully. Art too had played a role in this initially underground movement, as Sigler knew from her 1970s membership in Artemisia Gallery, a Chicago feminist cooperative.

Text and image would be her tools, and beginning in 1992 *Walking with the Ghosts of My Grandmothers* would be her agenda, evolving into the *Breast Cancer Journal* and comprising since then about 90 percent of her work as an artist. The title of the very first image in this ongoing series set the tone: *The Illusion Was to Think She Had Any Control over Her Life.* Beginning there and in many subsequent works Sigler has sought to overcome cancer's stigma, to use the vehicle of art to tell others, both those with breast cancer and those without it, of her own situation and the clinical realities of cancer today, to begin to defeat the illusion and in so doing to assert some control over her life. In the more than one hundred works to follow, Sigler has sought relentlessly to instruct and inform, to combine the dynamics of the poetry of imagery with the prose of text in works of art that lay bare the consciousness of a highly skilled communicator who knows her time may be short. The series has speed and impetuosity. Sigler is in a race to tell her story, jamming her frames and spacers with texts chronicling all the various strains of information that reach her, using her platform as an artist to create a place where people can come together and share their knowledge and experiences. (It is easy enough now to see this series as a vital and heroic development; too quickly one can forget how in its first several years the *Breast Cancer Journal* was quite ambivalently received. People were often surprised to encounter such profound and personal subject matter in an art context, and many were resistant, doubting that cancer could be a fitting subject for art and seeing the series as functioning somewhere in that misty zone between art and political activism.)

Certain symbols recur throughout the series—nature's wounds are manifested in images of blasted and denuded trees, the sense of

civilization gone awry made clear in scenes of abandonment and decay. Things are afire or rent asunder, there is an overwhelming sense that all can never be put right again. The Lady, Sigler's personification of herself and of all women similarly situated, waltzes faster and faster through this intensified world, trying to find meaning, trying to glean some understanding in the midst of disaster. The Nike figure becomes a harbinger of hope, the promise that in the future, perhaps very very soon, a cure will be found. Simultaneously didactic and evocative, ranging from moments of crushing despair to leaps of giddy exhilaration, the *Breast Cancer Journal* allows every facet of Sigler's ruminations to come through. It is a testament to determination; it is a response to the dictates of death.

For after all, it is not death we fear so much, but dying. The dribbling away, the descending cycle of loss, the embarrassment of diminution, the sense of betrayal that our own body, our companion, our friend, could carry within it the seeds of our destruction. Artists have often been merciless transcribers of their own mortality, and there are moments in Sigler's work when I am reminded of late works by Rembrandt or Pablo Picasso or Ivan Albright, when these artists looked squarely into the face of their death. But these were then old men, and while death might often be delayed, it never will be denied. Another artist I sometimes think of in relation to Hollis Sigler is Frida Kahlo, another fiercely independent woman whose lifelong history of extraordinary physical ailments and tribulations makes her work a poignant act of defiance and victory. The suffering of the body can, of course, become a metaphor for the suffering of the spirit, and the knowledge and understanding of self achieved through such a struggle can be both painful and precious. The work of Kahlo and Sigler is of this ilk, of a wisdom bought through vulnerability and pathos, of a fundamental affirmation of the possibilities of life discovered in the midst of agony and loss.

The *Breast Cancer Journal* is displayed within these pages for your examination and reference. Allow me to write a few words about one of these images, just one culled out of this litany of hope and understanding. *Is This Wishful Thinking? Maybe Not,* a small monoprint from 1996, seems at first one of the more modest pieces in the series. In it Sigler renders against a reddish and purplish sky three blasted and stripped trees (a metaphor for the Three Crosses?) that seem more dead than alive, with their broken branches strewn all over the ground. This is a desolate place, a forlorn landscape of gloom and death. In the foreground Sigler depicts a chair and an artist's drafting table, all set up for work. No artist is present. On the table is a drawing of a tree. But that tree is alive, its branches bursting with leaves, exploding with the promise of health and vitality, fully active in the cycle of life. This

HOLLIS SIGLER: AN APPRECIATION

BY JAMES YOOD

is the particular wonder of Hollis Sigler, to look squarely into the face of mortality and see it as an aperture between promise and despair. It is art that provides this transformation, art that permits this power to suggest and cajole, art that can reveal intimacies and open a visionary window to the very profoundest of truths. Sigler's entire career has been a testament to the communicative graces of art, and in the *Breast Cancer Journal* she reminds us that art can accomplish this in a way that nothing else can, and that sometimes, preciously and rarely, it will do very much more. Sometimes art can be a matter of life and death.

HOLLIS SIGLER: AN APPRECIATION

BY JAMES YOOD

TO KISS THE SPIRITS

MY BREAST CANCER JOURNAL

BY HOLLIS SIGLER

I began doing artwork in the style seen in this book in 1976, nearly a decade before my diagnosis of breast cancer. A different crisis, an emotional one, changed the way I was making art. Not knowing what to do with intense feelings of victimization, I put down my paintbrush and began drawing without restraint, like a child. These spontaneous pieces helped me more than conversations with friends or psychotherapy. Drawing was my salvation. It completed me.

Many women artists during the 1970s had a similar need to express emotions as the content of their art. "The personal is political" was one of the mottoes of the women's movement. What happens on a personal level was considered valid as a source for making art. This ran counter to an intellectually driven, male-dominated art world. My *Breast Cancer Journal* came out of this context.

Although I wanted emotions in my art, I was determined to be silent about their cause. Emotions are a common denominator; what causes the emotions—specific events, traumas, successes—are particular to the individual. I felt that art that was too particular about the cause ran the danger of being self-serving. I wanted my work to be about sharing or empathy and communication. I wanted the viewers to have a dialogue with the art, to be able to put themselves in the picture. To illustrate: you have a dream that is emotionally powerful. You wake with the dream coloring how you feel throughout the day. When you relate that dream to another person, it is not easily understood because the other person does not share the same icons and

images in their dreams that you do. But they can relate to having a dream so powerful as to influence their life. That is the quality I wanted in my art. Commenting on my work, one woman said the paintings were "echoes of my thoughts." The works should touch us in our shared emotional spaces.

When I had a recurrence of breast cancer in 1991, I broke with that way of thinking. The works in *The Breast Cancer Journal: Walking with the Ghosts of My Grandmothers* named the impetus for the emotions: my own experience with breast cancer. I took this risk hoping the work would thus gain the power to destroy the silence surrounding the disease.

In the course of learning about breast cancer, I had accumulated many facts and statistics, but I did not know how to incorporate these in my artwork. My frames provided the answer. I had the frames constructed to give enough room for me to write directly on them. Framed drawings provided yet another avenue, for there is a small space between the paper and the glass maintained by strips of painted wood one-half inch wide. Additional words could be written on these "spacers," making them physical metaphors for known facts or private thoughts about breast cancer. They can be glimpsed by the viewer but not easily read unless the frame is removed. In the first pieces of the *Breast Cancer Journal,* the inside spacer contained facts and statistics on the disease, while the outside frame space related to my diaries or to Audre Lorde's *Cancer Journals,* an account of the African-American poet's experiences as a cancer patient. (She succombed to the illness in 1992.) These early images were very emotional, and the diary entries complemented them. In later pieces, as I gained some emotional distance, the facts became more important and I reversed the procedure: diary entries would go on the inside spacer and the facts would go on the frame.

I did three preliminary drawings related to breast cancer and took them to Printworks Gallery in Chicago, where they were shown privately to a few collectors. The response of the women collectors surprised me. I expected them to be somewhat accepting of the subject matter, but the content was very disturbing to them, even those who had breast cancer themselves. They did not want to be reminded. In spite of all the accomplishments of the women's movement, women were still living with their fear in isolation from one another. Cancer was still a taboo subject. I began to appreciate the politics of breast cancer; medicine, dominated by male culture, effected a closeting of women's illnesses by not including women in trial studies, nor focusing much attention on women's illnesses in general. This closeting of women's experience had the effect of increasing women's sense of humiliation about their bodies; the loss of one's breast(s) jeopardized a

woman's sense of femininity and excluded her from feeling normal.

The original *Breast Cancer Journal* pieces were executed after these first three drawings. Something unexpected happened right from the beginning. I had anticipated discovering different metaphors in response to cancer's entrance into my life. I think of my work as visual poems, and individual visual metaphors are very important to the pieces. These metaphors, or icons, have become part of a vocabulary I have used to explore my emotional life on paper. Instead, I found that, in the spontaneous method I use, many of the same icons I have used before reappeared, but they acquired new meaning. For example, in the *Breast Cancer Journal* pieces, the vanity showed up again. I have always found it fascinating that we have a piece of furniture called a "vanity," and I have used it frequently as a symbol since 1976. I had always meant vanity, literally: a place where women view their bodies with admiration. Now, the nature of the object "vanity" meant something different. The body was no longer whole. The shattered image of the vanity's mirror reflected woman's pain, her fragmented sense of self.

Sometimes an image would change slightly or an entirely new element would appear. I introduced to the drawings the image of a dead and broken tree. The Lady (a consistent personality in my narratives, but one who is never seen except on rare occasions as a shadow) is trying to repair the tree by reattaching the branches. It is a fruitless gesture on her part, for it will never again be a living tree. The dead tree is the old self, the self before cancer. The Lady is struggling with irreversible life changes. I remember reading a newspaper article telling of a woman with breast cancer who had spent an hour in front of my journal pieces. According to the article, she was drawn to the broken trees. "It's never the same," she was quoted as saying. "But it's standing up. It looks like a tree."

These first works directly discussed my feelings concerning day-to-day experiences after my diagnosis. As time passed, my work became more reflective. The drawings and paintings evolved to cover many different aspects of the lives of cancer patients. Part of this reflection involved my reading and studying. Each of my exhibitions of the cancer-related works has had a different focus, often as a result of this study.

A group of drawings done almost immediately after *Walking with the Ghosts of My Grandmothers* came from my readings of Tibetan Buddhists, specifically *The Tibetan Book of Living and Dying* by Sogyal Rinpoche. That book, along with *The Cancer Journals* of Audre Lorde, gave me perspective, especially about my attitude toward permanence. It was a revelation to me, just as it had been to Lorde, how I had treated everything in life as if it were permanent. I "forgot" that I

vanity

would eventually have to leave my body, which I had viewed as a permanent residence. Suddenly I grasped the temporality of everything, even death. This viewpoint was refreshing. I was comforted to see myself as passing through this life on a visit—perhaps not making all the stops I wanted, but trying hard to take in as much as possible along the way. My consciousness about time continued to change. Just being alive was amazing. The past and the future had no reality. They were illusions. For example, how was I to view a concept like "retirement"? Putting off anything until the future seemed self-defeating.

Doctors sometimes tell their patients not to project into the future, that there is no way of knowing what will happen. I think this is helpful advice. Because of my situation, I have been forced to deal with the limited amount of time we all have, something that at first caused a great deal of anger in me. There had been periods of my life when I was really miserable, much more miserable than I have ever been since the diagnosis of cancer. I was in my twenties, and I was so very dissatisfied with life. I was terribly anxious, worrying about *everything*. Suffering from perfectionism and limited coping skills, I benefited immensely from therapy then. But now I am even more relaxed. Today I can say I am really quite happy, even living with a diagnosis of cancer. The main reason for this happiness is my letting go of the need for control, which the experience of cancer actually facilitated. Also, I feel a satisfaction with my life. I take advantage of opportunities in the present. In the past, I would put off chances for play in order to get some work done. Now I choose enjoyment, especially of the simple things, and without guilt. This is the good news, or one of the blessings, of my situation. I have no choice but to live as fully as I can in the present.

This was not supposed to happen at all, I was not supposed to get sick. At least, I did not think I was old enough to have this happen to me until maybe when I was fifty-seven, my mother's age at her diagnosis. But in July 1985, at age thirty-seven, I was diagnosed with breast cancer. At 4:00 P.M., I remember exactly, my fingers found a lump the size of a pea. All day long I had been feeling under my arm because of a persistent ache. I mentioned my discovery to my friend Leah Isadore, a fiber artist. She and I had been sweating over a quilt project, working on the fourteenth floor of a Columbia College building in Chicago, overlooking Lake Michigan. We agreed I should call a doctor and continued our stitching. But I knew deep down it was a bad sign.

The following weeks were hell. I had been living in a small farmhouse with my girlfriend of eight years, Patricia Locke, a jewelry

designer. We were moving into a new, larger home and at the same time dealing with this worrisome lump. The doctor who saw me the day after I found the lump had been investigating various diagnostic possibilities. About a week later, just before lunch, I went to the hospital to get a mammogram. Before I had even finished eating my lunch, someone from the doctor's office called, asking me to come in after hours. I was scared. One thing I knew—Patty was coming with me into that office.

When the doctor told me I had breast cancer, I was relieved. That sounds strange, I know, but I was more anxious being in the dark. Besides, I told myself (revealing my ignorance), my mother had been diagnosed with breast cancer and had survived. In other words, no big deal . . . I hoped. Patty, however, was much more devastated. She understood immediately the gravity of the situation and took on calling the surgeon's office to schedule a biopsy.

The biopsy confirmed what had been seen in the mammogram. Two weeks later I had surgery. My right breast was removed, and evidence was found of cancer in three of my lymph nodes. This meant I already had a stage two breast cancer. (There are four stages to the development of breast cancer: one is cancer at an early stage, when the tumor is less than two centimeters and no nodes are involved, through the fourth stage, when the cancer has metastasized to other parts of the body.)

The operation was followed by chemotherapy—"garden variety," as my oncologist, Janet Wolter, referred to it. Though I love her, I detested the weapons she used: surgery and chemical "bombs." I felt I had lost control of my body, first to the cancer (images of rampant armies of cells), and then to the doctors with their vicious counterattack. Metaphors of war are sadly apt. Though my life had been saved by a punishing therapy (I am grateful, make no mistake about it), I learned it need not ever have gone that far. If the cancer had been detected early either through self-examination or mammogram, I could be cancer free today. Two years before my diagnosis, during a regular visit to my gynecologist, I had mentioned that my mother had just been diagnosed with breast cancer. His response was to tell me not to worry. Furthermore, he said it was not necessary to do a baseline mammogram until I was forty (I was then thirty-five). If I had known more about breast cancer, I would have insisted on one then.

It was a time of pestilence. In 1985, one in nine women would develop breast cancer in her lifetime, up from one in twenty in 1960. The disease had reached epidemic proportions, but it was a silent epidemic. There were no headlines. There were no speeches from the surgeon general. There were no cautionary articles in the women's section of the newspaper.

Meanwhile, I went for periodic checkups at the hospital, and I was being monitored by the doctors to see if they had defeated this killer. My body was still out of my control. I reacted to feeling out of control by (unconsciously) being obsessed with maintaining control. I became afraid of change and uncontrollable situations. I developed, as one example, an enormous fear of flying and started taking trains to go anywhere. I took a train to get to Florida so I could work on prints at the University of Tampa. Likewise, I took one to Arizona to do more prints. I did a whole train trip of the northeastern United States to lecture as a visiting artist at various locations. I call this my "stiff-arm period"—because I was protecting what I had from any change. If nothing changed, the cancer could not come back. This period lasted almost five years.

Those five years were not easy. For one thing, I discovered that I was locked into my job at Columbia College, where I had taught since 1978, because of my dependency on the college's health insurance. As a cancer patient, I could not quit my job and hope to get other coverage. My dream of leaving teaching to devote all my time to my art was now an impossible one. Though I love teaching, this restraint on my freedom made me feel as if I was a prisoner. I wished, and still wish, for a national health care system that is fair and benefits everyone.

While struggling emotionally, feeling trapped, vulnerable, and angry, I worked very hard to maintain a normal life. I did my art, taught, continued my relationship with Patty, and was active socially. Even so, during this time I refused to wear a prosthesis or to have reconstructive surgery. By not looking normal, I made a few people, at least, aware of the fact of breast cancer. I became quite comfortable not wearing a prosthesis even in a bathing suit. This gesture, fueled by anger, marked the beginning of my activism. How could we, as a society, know about this epidemic if all of us one-breasted women looked as if we were intact? This "cover up," as I saw it, further separates men and women. Where women crave compassion for their struggles with mortality, acceptability, and love, they deny themselves the opportunity for caring responses. The men in their lives suffer from this cover-up as much as do the women. How can they be compassionate if they are not aware of the fact that many, many women have been diagnosed with this disease? After all, these women are their wives, sisters, mothers, and daughters.

Five years was the golden number. If I could be cancer free that long, it was possible I had beaten this disease. I had survived for five years by 1990 and was feeling better about my chances when I had my first recurrence. Near the scar on my chest there appeared suddenly a small spot resembling a spider bite. It did not itch and it was not going away. I prayed it was nothing. The oncological surgeon also

thought it could be nothing. It was too soft to be malignant, in his opinion. But after out-patient surgery, the verdict was cancer. The follow-up treatment was six weeks of radiation. I hated submitting my body to more painful, damaging procedures.

During the fall of that year, 1990, I enrolled in the "I Can Cope" program of the American Cancer Society at Lake Forest Hospital. The program combined support and education. Medical experts were brought in to answer questions concerning nutrition, exercise, medical procedures, life-style, and the like. I learned from different voices. My oncologist, for example, would never have discussed the benefits of meditation. The program was great. It was my first introduction to other cancer patients. The courage these people showed as they faced various cancers and treatments gave me strength.

This strength was tested very soon. The following year I developed terrible sciatic pains. I visited my general practitioner who, because I was a cancer patient, immediately ordered a bone scan. It was a Friday when I received the results of the test. The cancer was showing up in my bones: it was a stage four breast cancer. This was possibly the worst weekend of my life. I was sure I was going to die soon. I spent the weekend as a visiting artist in Madison and Oshkosh, Wisconsin. Driving in the car between lectures, I was only more depressed by the music on the radio. There was one song in particular by Tom Paxton:

> *Are you going away with no words of farewell?*
> *Will there be not a trace left behind?*
> *Well I could have loved you better, didn't mean to be unkind*
> *You know that was the last thing on my mind.*

I cried a lot. At forty-two years of age, I was looking squarely at my own mortality.

The following Monday I met with my oncologist, who assured me I was not at death's door. The prognosis? There were options. I began treatments with the hormone suppressor Tamoxifen, one of a number of drugs that suppress the estrogen that the cancer needs in order to reproduce. I had the option of a bone marrow transplant as a last resort. My doctor said I should not expect to be an old woman.

In America, from 1981 to 1994, there were more than twice as many women who died of breast cancer (620,000) than people who died from AIDS (270,000). It is a maddening statistic because, through the unfortunate comparison of two terrible tragedies, it illustrates the deleterious effects of power on our health care system. National Institutes of Health (NIH) statistics tell us that during that time period approximately ten times more money was spent on AIDS research

25

than on research for breast cancer. An epidemic was raging, but nobody talked about it.

I threw myself into studying breast cancer. And I wanted to use what I learned to make new artwork explicitly about this disease. By then I was a changed person. The realization that there was nothing to lose, only something to gain, was the most empowering part of my experience. I was determined to make something good come out of a situation that was not good. On the wall of deadly silence about the disease, I aimed to hang my *Breast Cancer Journal*. This work was an outcry.

The first twelve pieces of my *Breast Cancer Journal* were shown in 1992 in Mill Valley, California, at the Susan Cummins Gallery. Susan was shocked by the work. Not only was this my first show at her gallery, but she had been expecting my usual work and not the explicit pieces I had made. Nevertheless, she took on the challenge and worked hard on new strategies to bring people in. Logic suggested reaching out beyond the usual art audience to the community affected by the disease: women in general, cancer patients, their families and friends. Susan contacted the Cancer Center at nearby Marin General Hospital. With the help of Beverly Dector, director of Marin General's Humanities Program, several events, such as panel discussions on the topic of breast cancer, were scheduled at the gallery to attract the public. These discussions were led by experts in the medical field, including oncologists, oncological nurses, social workers, and hospital administrators. For a small community, a turnout of fifty plus people for the first event was encouraging. The audience was seated on folding chairs in the middle of the gallery, surrounded by my pieces. They expressed their anxieties and ignorance about the disease to the panelists. Some medical people were also in the audience and shared their knowledge and experience. Also, and very important to me, there was a decided interest in the artwork. Comments made through the duration of the exhibition indicated that people were moved and grateful for the work. Thanks to Susan, Beverly, and others, a healing dialogue had begun.

However, only one piece from the show sold (this piece was then donated to Marin General Hospital's Cancer Center). Then, to my amazement, a single story in a fashion magazine changed everything. Patty Locke had talked up the show on my behalf to Ruby Rich, a freelance writer and cultural critic at *Mirabella* magazine. Her article on the exhibition appeared in the March 1993 issue. Within a year of the article the show had sold out to collectors (not all affected by breast cancer) from all over the country.

Also in 1993, Maureen Gustafson from Rockford College in Illinois contacted me for a show of my work to coincide with

Women's History Month. She, like Susan, had not been aware of the *Breast Cancer Journal* work. I saw her offer as an opportunity to bring these pieces to the Midwest. I hoped we could do what we had done in California—engage the community. Maureen, a newly appointed curator, was willing to take a chance. She enlisted the Rockford Memorial Hospital's Women's Health Advantage, an advocacy group working to promote women's health issues. With funds raised by the Health Advantage, a full-color catalogue of the twelve original pieces was produced. (The catalogue is in its second printing, and ten thousand copies are in print.) Again, the show was well received and well attended.

In the course of a conversation between Ruby Rich and Susan Sterling, curator of the National Museum of Women in the Arts, Ruby insisted that Susan look at the *Breast Cancer Journal.* Susan had been familiar with my work through knowing Steven Scott, my dealer for ten years in Baltimore, and Helaine Posner, a former curator at the National Museum of Women in the Arts. Helaine had curated a show in 1984 at the University of Massachusetts, entitled *Domestic Tales,* which included my work. The show intrigued Susan, who was always on the lookout for new ideas.

Everything happened in a whirlwind. In less than five months Susan had the show up at the museum in Washington. Since the catalogue had been prepared by the Rockford College Art Gallery, Susan had the time to organize outreach efforts. She learned that Sally Anderson, who handled public relations for the Museum for Women in the Arts, had contacts with the National Breast Cancer Coalition (NBCC). It so happened that the coalition had an event planned in Washington during October, National Breast Cancer Awareness Month. It was a petition drive to call for increased funding from Congress for breast cancer research. Susan decided, with the coalition's help, to schedule the show's opening to be the kickoff for the petition drive. She also met with Hope Gittis Sheft from Revlon Corporation (already, at 2.4 million dollars, a big donor to breast cancer research), who agreed to sponsor the show and a march to deliver the petition to President Bill Clinton at the White House.

On the day of the opening, I attended a luncheon at Blair House with eleven other breast cancer activists. We were the guests of Annita Keating, wife of the prime minister of Australia. She wanted to pick our brains for strategies to help inform the Australian public about breast cancer.

That afternoon I talked with the press about my work and breast cancer: Cable Network News (CNN) for television and National Public Radio (NPR) and Voice of America for radio. At 6:30 P.M. I went to the museum for the opening of my exhibition. Hundreds of

people from all over the country packed the museum. It was an unbelievable and inspiring thing to see. There I met for the first time Dr. Susan Love, surgeon and author of *Dr. Susan Love's Breast Book,* an indispensable resource for women. I also met veteran broadcaster and breast cancer survivor Linda Ellerbee. These two spoke, along with Fran Visco, president of the National Breast Cancer Coalition, and Jim Conroy and Hope Gittis Sheft from Revlon, and myself.

I was surrounded by people who were working to rid the world of this disease, and many, like me, who were fighting for their own lives. I was not isolated anymore. My work, in a way that seemed miraculous, had connected me with a large group of humanity. Friends of mine from high school came to the opening, taking the train into Washington from New Jersey. Susan Cummins and Maureen Gustafson, women so important to the success of my work, had flown in. Even some collectors of my work came in from Chicago. It was a day I will never forget.

One month later I returned to Washington for the petition march. As representative for the National Museum of Women in the Arts, I was to be present in the East Room of the White House when the National Breast Cancer Coalition gave the petitions to President Clinton. We delivered more than 2.6 million signatures demanding a national plan to end the epidemic of breast cancer. After shaking hands with the president, I walked to the rally being held at the march's end. I listened to all the speakers and talked with many different women from various groups, such as Y-Me, an organization based in Chicago. After the rally disbanded, many women headed directly for Congress to lobby their individual senators and congresspeople. The petition drive proved to be a great success. Congress increased its spending for breast cancer research from 95 million dollars to 400 million.

Patty has recently suggested that my own activism is in some way responsible for my being alive today. This is a rather remarkable idea to consider, but I think it is true. The increase in funding research over the last decade has resulted in the kinds of drugs I am taking right now.

There is more to the story of the original twelve pieces. In 1993, prior to the Washington exhibition, Beverly Dector had flown to Washington to attend a Society for the Arts in Healthcare (SAH) board meeting. There she and Susan Sterling discussed their wish that my work be seen in communities across the country to help educate people about breast cancer. But there were significant problems with this idea of a national tour. The privately owned pieces were housed all over the country, making shipping potentially costly. Also, the pieces were fragile and the risk of damage to them great. Susan was

aware, however, of a new photographic technology, a process called photofacsimile, which produced high quality images. If the works could be photographed in Washington, while they were all together, reproductions could be made about the same size as the originals.

The National Museum of Women in the Arts and the Society for the Arts in Healthcare, in particular Lynn Kable, a veteran of producing programs that combined art with educational materials, teamed up to write a proposal to the Polaroid Corporation, asking the company to donate its technological resources. Polaroid agreed. And Susan Sterling offered to privately finance the cost of making frames for the replicas and boxes for them to travel in. Except for shipping costs, the show would be free to hospitals and wellness centers if they agreed to provide educational programs in conjunction with the art exhibition. Two of the programs were developed by the SAH, one relating to the art (with the help of my dealer in Baltimore), and one on living with breast cancer. A third program on early detection and education about breast cancer, including a free screening and mammogram day, was to be developed by each participating hospital. The SAH, using the catalogue published by Rockford College, was able to interest seventeen hospitals in eleven states in the project.

When I first saw the replicas here in Illinois, I could not believe how good they looked. The idea that many thousands of people have seen the work, not only in art galleries but on the walls of hospital corridors where people are actively struggling with this disease, thrills me. The tour, going on its fourth year, will have visited twenty-four hospitals and been seen by an estimated twenty thousand people. It has a life of its own. I liken it to a space probe that, as it travels, keeps on sending its message.

There have been a number of shows of the *Breast Cancer Journal* in various locations across the country. Some of the more important ones have been at the Museum of Contemporary Art in Chicago and the Fort Wayne Museum of Art in Fort Wayne, Indiana. The Museum of Contemporary Art show, in 1994, brought together twenty-five pieces from the journal. Including the initial twelve pieces, this exhibition formed the most complete showing to date of the *Breast Cancer Journal*.

The Fort Wayne Museum show, in 1995, titled *Working Towards Paradise,* was significant not only for the works included but for the level of community involvement. Numerous community organizations, coalitions, leagues, alliances, businesses, cancer centers, and individuals joined together to develop and sponsor events related to the exhibition. These included workshops on healing, a breast cancer awareness symposium, and a lecture and workshop led by Dr. Bernie Siegel, a leading advocate of self-healing. A group known as Women

Winning against Breast Cancer published a cookbook with recipes by celebrities. Proceeds from the sale of the book went to the Indiana University Cancer Center Research Program. I met many community members at the opening and was overwhelmed by their energy and dedication to fighting breast cancer. I felt proud to be a part of this movement.

One of the most difficult shows of the journal was *Tending the Garden* at the Carl Hammer Gallery in Chicago in 1995. The show included paintings made while my mother was dying of breast cancer. She had been diagnosed with breast cancer two years before I was. As with so many families in this country, many members of my family have had some form of cancer. My mother battled this disease for thirteen years. For most of those years she was fine, except for a few skirmishes. In the last year of her life she was in and out of the hospital several times. In April 1995 she was hospitalized for the last time. The cancer had settled in her spine. The doctors had decided to radiate her back to kill the tumor, which caused a vertebra in her spine to collapse, putting her in great discomfort. The radiation also destroyed her adrenal glands. Her body lost the ability to produce the steroids necessary to stay alive. She started to slowly die. She lost control of her thought processes. She would drift off into a world of her own, no longer available to us, though there were moments of lucidness. She stopped reading books, one of her greatest pastimes. She no longer watched her usual shows on television, like Masterpiece Theatre. And she no longer listened to the radio on Saturday afternoons, missing her lifetime favorite program, the Metropolitan Opera from New York. Instead, toward the end, she liked children's shows. My brother speculated that she enjoyed them because of the bright colors. I watched this happen to her over a period of three weeks. I tried in my paintings to convey a sense of slipping away, that as we die the spirit leaves the body bit by bit. Eventually, mysteriously, those we love are beyond our grasp.

In those particular paintings, I used a dress as a metaphor for my mother. The dress seemed the most appropriate symbol for her. She had a trim, well-proportioned body. Her legs were always beautiful, even as an older woman. As a small child, I saw my mother in dresses with full skirts in pastel colors. I remember on hot summer days traveling with my mother and brother to my grandmother's farm. While mom was driving, she would hike up her skirt for a cool breeze. She would say she was giving the truck drivers a thrill. It was a sexy moment because of the dress. Sometimes in the paintings I would depict a particular dress of hers, a dress I remembered from her

wardrobe. After she died there were closets of dresses that I had to dispose of.

Two weeks before the opening of *Tending the Garden,* my mother died, on April 19, 1995, one week before her seventieth birthday. I began to understand the whole process of dying. The process is not neat or clean. The dying are out of our control. What happens has no right or wrong to it; situations are left dangling. Good-byes do not always get said. The event is not witnessed by everyone who wishes they could be there. Issues that seemed so important for the living are suddenly placed in perspective. Dying is a singular event that has its own rules.

In *An Etiquette for Dying,* held at the Printworks Gallery in 1996, I used the medium of cut paper, a popular way of memorializing loved ones during the nineteenth century, to talk about this experience. My mother did not want to die. She wanted very much to stay with us. She did not want to leave her mother, who was still alive and in her nineties. She was concerned about who would take care of her mother if she died. And I remember her asking me how she was going to say good-bye to her mother. I told her she did not have to. The question becomes, is there really a way to prepare for death?

Not long after my mother's death, I received a call from Sherry Leedy of the Leedy Voulkos Art Center Gallery in Kansas City, Missouri, asking me to do a show on breast cancer for the following October. Her motivation for the show came from the recent death of her own mother from breast cancer. It was to be a tribute to her mother's memory. I took my theme for the show from information I had gathered about the causes of cancer—a subject much speculated about over the years. I used a much more objective approach to the subject than I had previously taken, because I needed the distance.

This show, which I titled *Causes and Cures,* was a journey into the mind's search for an answer. Every cancer patient asks the question: why did this happen to me? And everyone is taking stabs at an answer: is it genetic or environmental? Maybe it is both. In an encyclopedia from 1918 that I own, causes for cancer were offered, but the authors could only say with certainty that cancer was noncontagious. Over seventy years later the medical community still does not know the cause. What has become clear to me is that the causes are related to the cures. They are two sides of the same coin. If radiation can cause cancer, radiation can also cure it. Chemicals in the environment can cause the disease; chemotherapy can cure. There is a paradox at work here. So I did paintings in pairs that would reflect the two sides.

While driving in my car on a cold day in March 1996, I heard a news story on the radio that made my heart leap. The story was about the discovery of a gene that could inhibit breast cancer cell division.

In my diary I wrote: "Hope is out there waiting for us to find her. No one can know how exciting this news is to those of us with breast cancer. It touches every part of our lives, our feelings, our thinking, our believing. The world looks different again." For the first time since being diagnosed with cancer, I felt hopeful. This became the theme for my next show at the Susan Cummins Gallery, *Making a Deal with the Devil.*

From this moment the Nike (Winged Victory) of Samothrace took on a new presence in the paintings. She was now my symbol for hope. Hope had tangible meaning. The "victory" became the gene that might cure the cancer and stop the epidemic. I also realized that I would do almost anything to have this disease disappear from my body. I eternally hope to wake up and find my breast cancer gone. But I no longer linger over thoughts of how this happened to me. I do not dwell on how to cope with it either. My thoughts are about hope. I think about how to heal myself. I would like a cure, but healing and curing are two different objectives, for to heal is to reconcile myself to my situation. A cure is to be free from the disease. I want both, of course. But I can actively effect a healing more than I can a cure. I can feel whole again, complete. In healing, I restore my mind, body, and spirit to each other. That is where I find faith.

As I live my life with this disease, it becomes more abstract. I do not live with physical pain. I do not have to cope with the loss of physical abilities. I feel physically the same way I always have. Cancer has been an emotional trial mostly. But the emotional impact has changed my life forever. That is why I have found my experience more of an exploration into the realms of spirit, heart, and mind.

One day they will discover the cause and the cure. Whether I will live to see this happen is another question. In the meantime, I will continue to chronicle my journey along the way. Like all of us, I am just passing through.

In executing these pieces, it is important to me to be as spontaneous as possible. Being spontaneous gives me a sense of a child's joy in drawing, a joy unspoiled by a critical eye. The works are done, therefore, without any preliminary drawings. In most cases, I start with my diary, writing to myself, creating a dialogue with myself about the events of my life. This gives me a handle to the concept for a drawing. When I begin to draw, I make decisions as I go. I am often asked whether it is the words or the images that come to me first. Because I am working spontaneously, there is no set answer. Sometimes words come first and sometimes it is an image. I do not make any corrections to the drawings. There are drawings that do not work and they are rejected. I try to do the whole drawing in one sitting. I do this in order to keep in the moment, because if I wait, my sense of the situ-

TO KISS THE SPIRITS

BY HOLLIS SIGLER

32

ation changes. This can affect everything from color choice to my emotional connection to the work. In terms of the paintings, they do take longer; however, I still try to do the initial drawing on the canvas in one sitting. The painting then develops over time on top of the drawing. But I do not change the initial drawing the painting is derived from.

The inscriptions on the frames and the spacers are done as spontaneously as the drawings. I collect writings and statistics and use them to help tell my story. Sometimes I write quickly. I am not always grammatical or consistent, spellings may be wrong, and words may be skipped in my haste. Perfection does not concern me; the message does.

The paintings and drawings in this series are an ongoing story of breast cancer. Sometimes the works come close to my personal experience. Sometimes they fly off into the less personal realm and deal with general information about breast cancer. Together they tell the multisided tale of having a life-threatening disease. It is this experience, beyond the particular cancer, that can be shared by many of us. Crisis seems to bring out different parts of ourselves we do not always know we possess. Some people react as if the glass is half empty, others as if it is half full. I am interested in our responses to varied situations and how we cope. Cancer has given me a gift to be able to relate to those with a severe crisis in their lives. Each crisis has a loss *and* a gain. I would like to think that my experience with cancer has given me compassion about human frailty. I see how little we are in control. What we need most is faith.

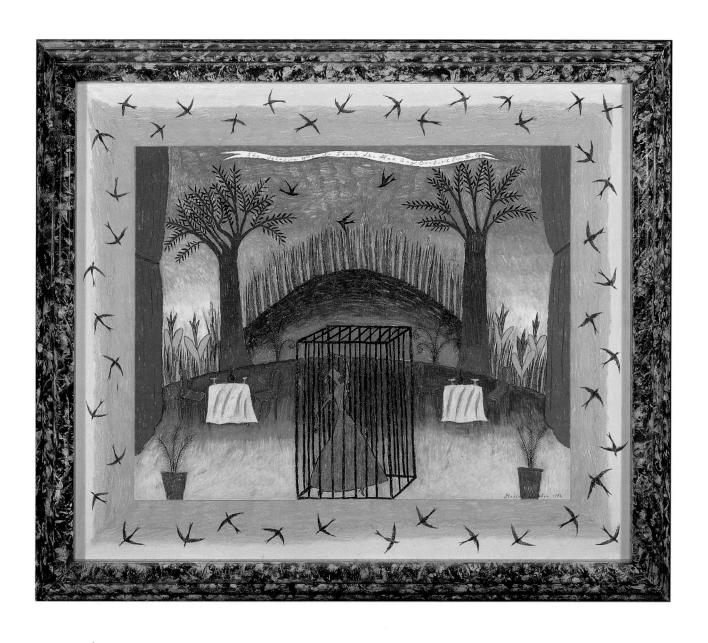

1 THE ILLUSION WAS TO THINK SHE
HAD ANY CONTROL OVER HER LIFE
1992, oil pastel on paper, 29″ × 34″ with
painted frame
Collection of Jacques Zimicki

SPACER: *"Although breast self-examination
has not reduced the incidence of breast cancer, it
does markedly reduce the rate of mortality,
since most early tumors are found by women
themselves."*

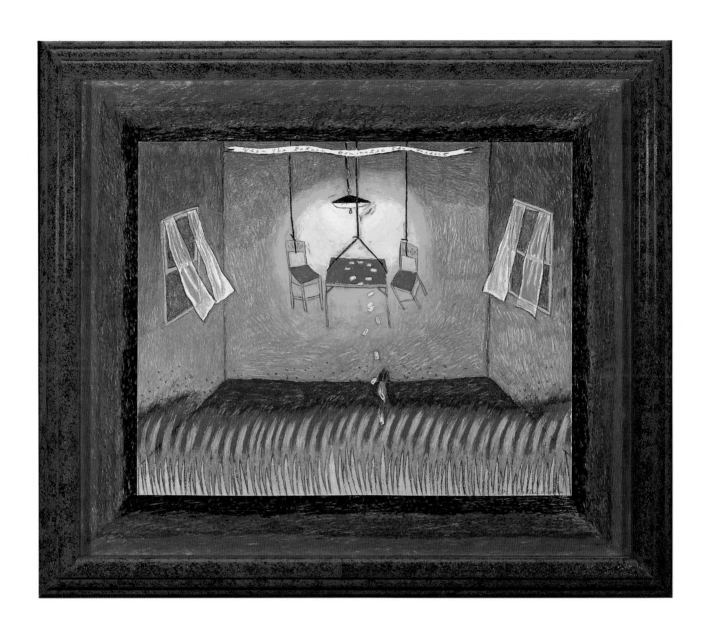

2 WHEN THE FUTURE DOMINATES
THE PRESENT
1992, oil pastel on paper, 29″ × 34″ with
painted frame
Collection of Laura and Larry Gerber

SPACER: *One out of every nine women in the United States of America will be diagnosed with breast cancer in her lifetime. In 1989, one American woman was diagnosed with cancer every minute and one woman died of cancer every 2.2 minutes.*

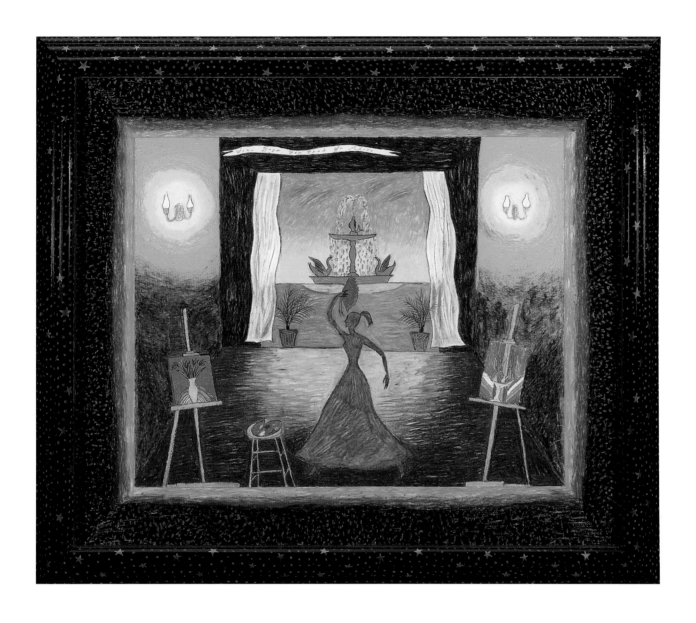

3 SOME DAYS YOU FEEL SO ALIVE

1992, oil pastel on paper, 29″ × 34″ with painted frame

Marin General Hospital, Greenbrae, California; gift of Susan and Bill Beech

SPACER: *"May these words serve as encouragement for other women to speak out and act out of our experiences with cancer and with other threats of death, for silence has never brought us anything of worth. . . . May these words underline the possibilities of self--healing." Audre Lorde,* The Cancer Journals

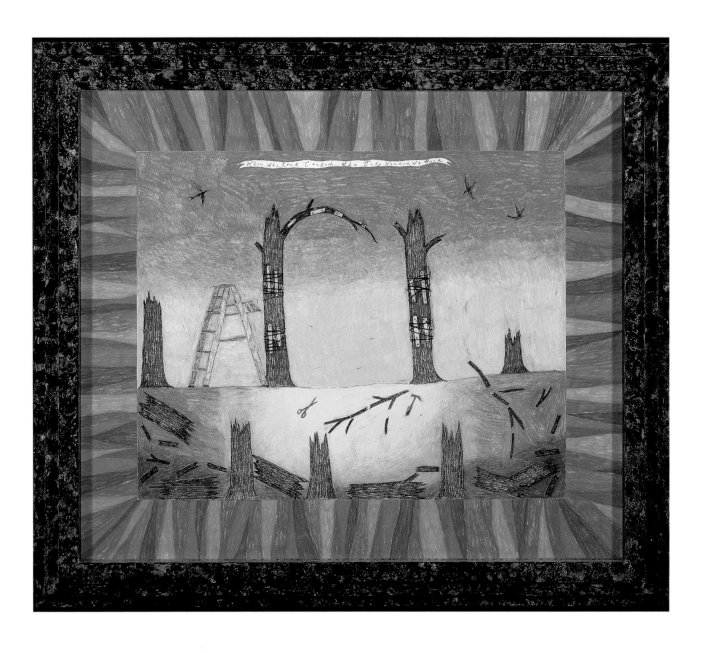

4 WHEN SHE LOST CONTROL,
SHE ONLY WANTED IT BACK

1992, oil pastel on paper, 29″ × 34″ with
painted frame

Collection of Jean Howard

FRAME: *45,000 women die every year from
breast cancer . . . Bette Davis . . . Jill Ireland . . .
Lynn Sage . . . Sarah Anna Truitt Ryan . . .
Women are dying . . . Florence Hansen . . . In
Memory of these women, this work is
dedicated.*

SPACER: *Divine love floods my body with
health; every cell of my body is filled with light
for the highest good. Divine love floods my
body with health; every cell of my body is filled
with light for the highest good. Divine love
floods my body with health; every cell of my
body is . . .*

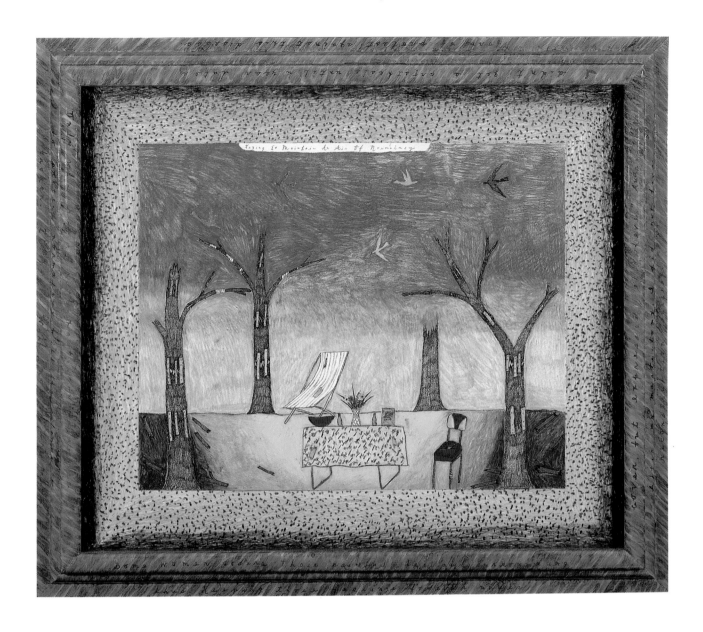

5 TRYING TO MAINTAIN AN AIR OF
NORMALCY
1992, oil pastel on paper, 29″ × 34″ with
painted frame
Collection of Jean Howard

FRAME: *"Some women obscure their painful
feelings surrounding mastectomy with a blanket
of business-as-usual, thus keeping those feel-
ings forever under cover, but expressed else-
where." Audre Lorde. After my mastectomy, I
did not have reconstruction surgery. I didn't get
a prosthesis until a year later. I often don't
wear my prosthesis, it's my form of protest
against this disease. Only when women with
mastectomies refuse to pretend normalcy will
the silence be broken. The world will know we
are many.*

SPACER: *One in three American women
will get cancer in her lifetime; nearly 1 in 4
American women will die of cancer. In 1989,
one American woman was diagnosed with
cancer every minute and one American
woman died of cancer every 2.2 minutes.*

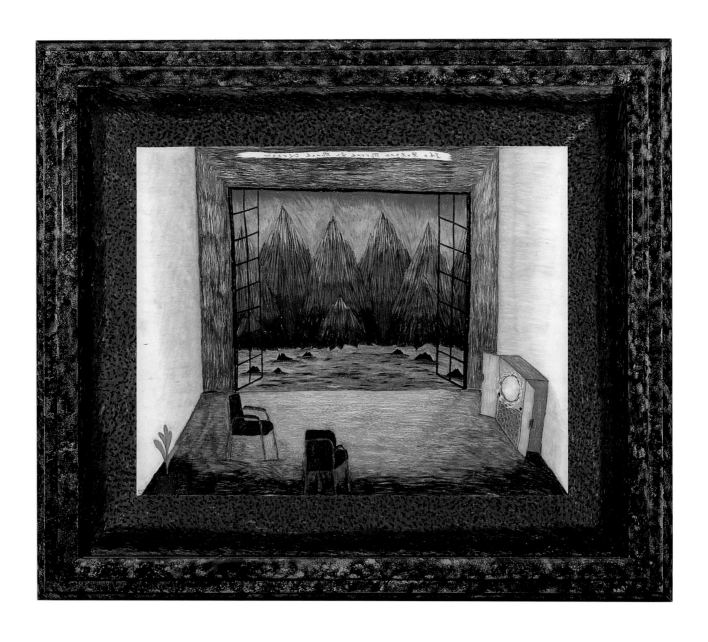

6 THE FUTURE MOVES IN MUCH
CLOSER
1992, oil pastel on paper, 29″ × 34″ with
painted frame
Collection of Susan Cummins

FRAME: *In losing a breast, there is a sense of loss. It is a feeling I own only to myself. But fear of recurrence took a hold of my life. The illusion of fear has been lost when I encountered my cancer for a third time. There is nothing to lose now.*

SPACER: *One out of every nine women will get breast cancer in her lifetime, 25% of white American women with breast cancer will not live more than 5 years and 40% of black American women with breast cancer will not live more than 5 years.*

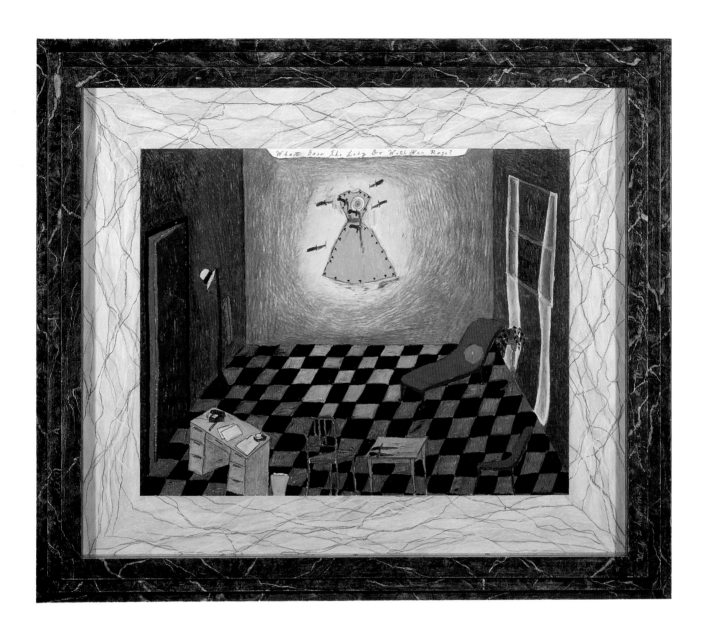

7 WHAT DOES THE LADY DO WITH
HER RAGE?
1992, oil pastel on paper, 29″ × 34″ with
painted frame
Collection of Dale Gordon Davison

FRAME: *And where does the anger go? What
am I supposed to do with my anger? My emo-
tions fluctuate between feeling sorry for myself
and rage. And then there is the thought that
this is all a bad dream that will go away.*

SPACER: *As far back as 537 B.C. the ancient
and respected physician Galen noted that
women who were depressed and melancholy
were more apt to get breast cancer than cheerful
ones. "A Psychological Study of Cancer," it
was found that grief (due to a loss) of a signif-
icant relationship was the most predisposing
cause in cancer.*

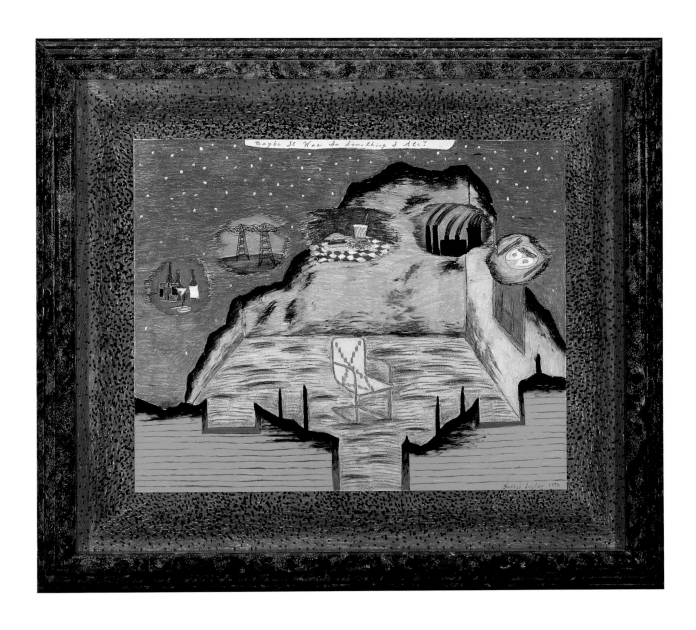

8 MAYBE IT WAS IN SOMETHING I ATE?
1992, oil pastel on paper, 29″ × 34″ with painted frame
Private collection, Annapolis, Maryland

FRAME: *The guilt of responsibility—could I have wished this on myself? In this culture, which places so much emphasis on the individual, it is seen as a personal failing if one has a disease. What did I do wrong? Can I make it right again?*

SPACER: *Because Japanese women have one of the lowest cancer rates in the world (especially for breast cancer), it was felt until recently that they had inherent racial resistance. But now we know that Japanese women living in this country for ten years or more have a breast cancer rate equal to that of U.S. women.*

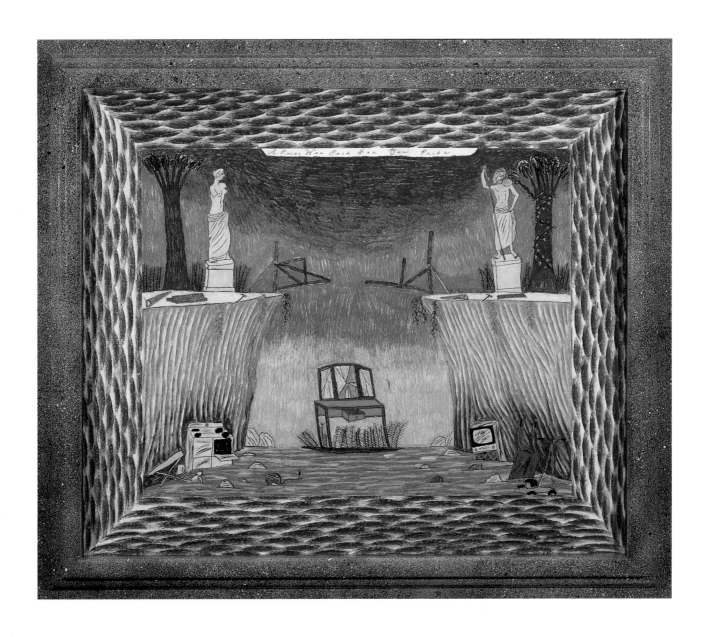

9 A PRICE WAS PAID FOR OUR PRIDE
1992, oil pastel on paper, 29″ × 34″ with painted frame
Collection of Laura and Larry Gerber

FRAME: *I used to pretend this never happened. But the disease won't go away. I live with it every day. My silence has victimized me. My silence left me powerless. Without my voice fear, I can speak about breast cancer and other diseases of women.*

SPACER: *"Remember what we are doing in the reconstruction of the female breast is by no means a cosmetic triumph. What we are aiming for is to allow women to look decent in clothes. The aim is for the patient to look normal and natural when she has clothes on her body." Dr. Steven Gallegher*

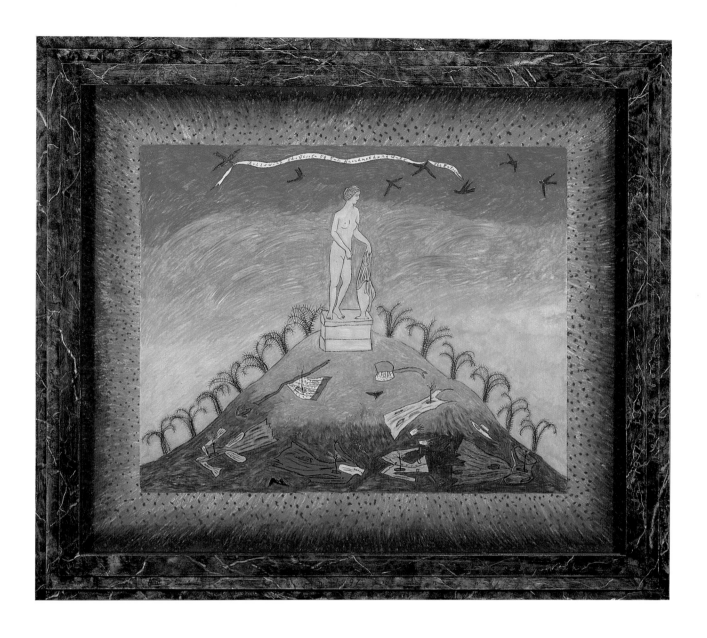

10 FOLLOWING THE GHOSTS OF OUR GRANDMOTHERS INTO THE FUTURE

1992, oil pastel on paper, 29″ × 34″ with painted frame

National Museum of Women in the Arts, Washington, D.C., gift of Steven Scott, Baltimore, in honor of the artist

FRAME: *In 1960, one in twenty women were diagnosed with breast cancer. In 1992, one in nine will be diagnosed with breast cancer alone. I was diagnosed with breast cancer in 1985. I had a mastectomy, which was followed by chemotherapy. In 1990, I had a recurrence of the cancer which was treated with surgery and followed by radiation. In 1992, the cancer was found in my pelvic bone and my spine.*

SPACER: *It has been projected that in the year 2000, one in every seven American women will be diagnosed with breast cancer. We don't know why the increase is occurring. Only 90 million dollars is spent on breast cancer research by our government, over 300 million dollars is spent on AIDS research.*

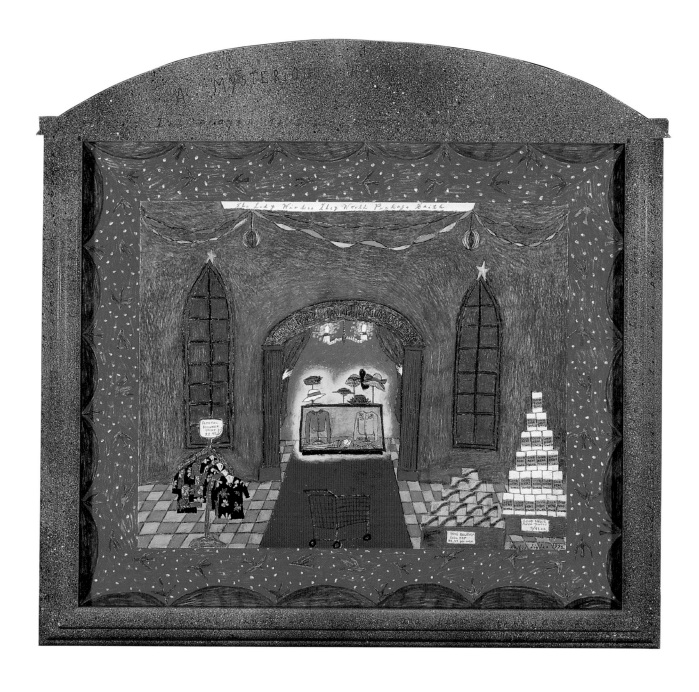

11 THE LADY WISHES THEY WOULD PACKAGE FAITH

1992, oil pastel on paper, 32″ × 34″ with painted frame

Collection of Jacques Zimicki

FRAME: *A mysterious Recovery: the prayer of every cancer patient: asking people with cancer to change their belief to understand that they can recover and live a full and rewarding life—despite their own fears about the disease and negative expectations of the people around them—is asking for a great many acts of courage and personal strength. The same power that allows us to create negative experiences can be used to create positive experiences.*

SPACER: *Dr. Lawrence LeShan, a psychologist, found in a controlled study of 500 cancer patients the following pattern: childhood isolation and despair, poor parental relationships, establishment in adult life of a strong relationship or job into which much energy was poured, subsequent loss of this relationship or job leads to feelings of childhood. Within six or eight months later cancer appeared.*

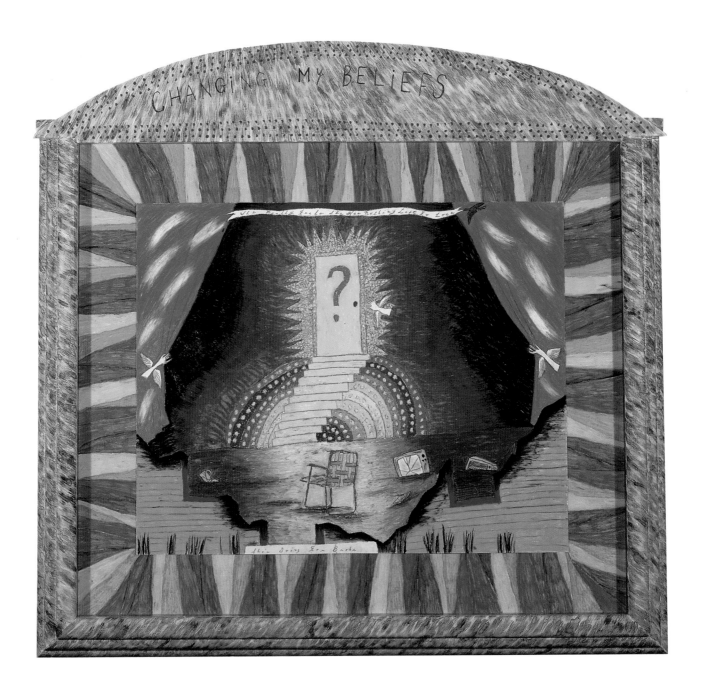

12 SHE REALLY FEELS SHE HAS
NOTHING LEFT TO LOSE
1992, oil pastel on paper, 32″ × 34″ with
painted frame
Collection of Julius Shapiro

FRAME: *Changing My Beliefs*

SPACER: *"Surrounded by other women day
by day, all of whom appear to have two
breasts, it is very difficult sometimes to remem-
ber that I AM NOT ALONE. Yet once I
face death as a life process, what is there possi-
bly left for me to fear? Who can ever really
have power over me again?" Audre Lorde*

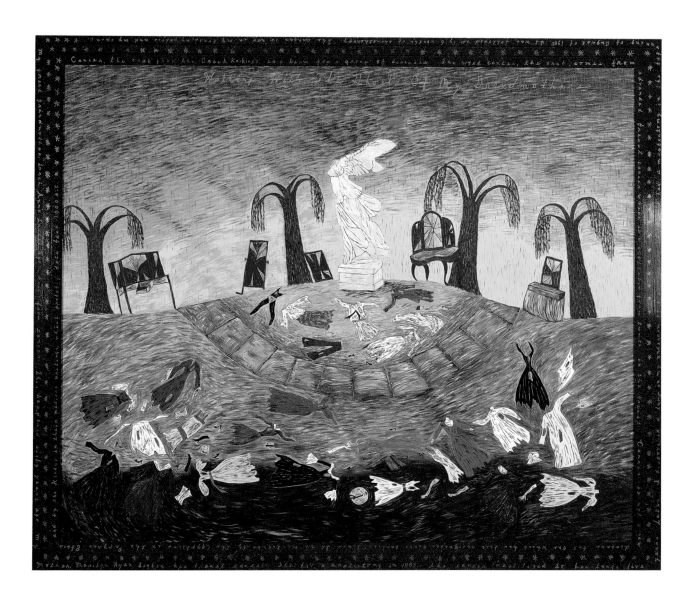

13 WALKING WITH THE GHOSTS OF MY GRANDMOTHERS

1992, oil on canvas, 54″ × 66″ with painted frame

Collection of Laura and Larry Gerber

FRAME: *Cancer, the crab from the Greek Karkinos, is a term for a group of diseases. The word cancer, the crab, comes from advanced breast cancer which is a stellated form tumor in the breast. Cancer is not a new disease but one which has been recognized since earliest times. It is mentioned by the Egyptians in the Papyrus Ebers and by the Hindus in their medical writings, which probably date back 2000 B.C. My great grandmother Sarah Anna Truitt Ryan died from cancer. This happened sixty years ago. My mother Marilyn Ryan Sigler, has breast cancer. She had a mastectomy in 1983. The cancer metastasized to her lungs five years later. I discovered a lump in my underarm on a summer day in 1985. I had a mastectomy in the beginning of August of 1985. It was followed by 6 months of chemotherapy. The cancer is now in my bones, my pelvis and my spine.*

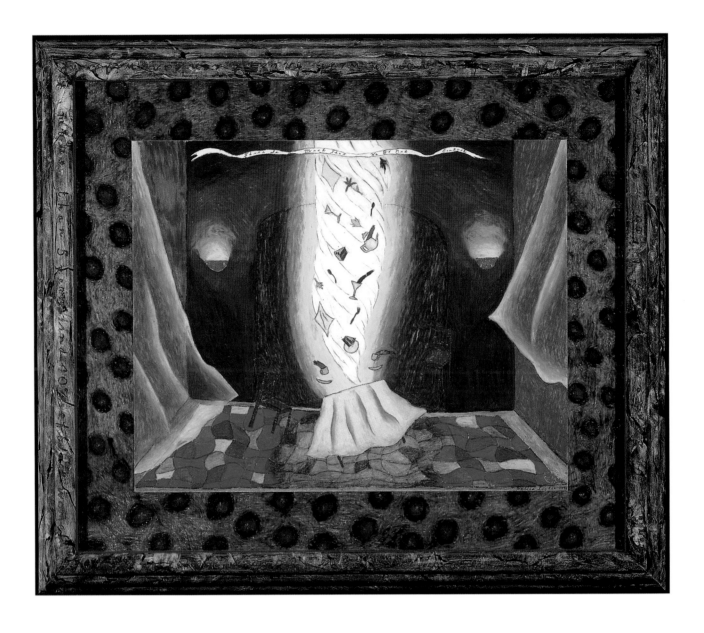

14 THERE IS MUCH THAT WE DO NOT
CONTROL
1993, oil pastel on paper, 29″ × 34″ with
painted frame
Collection of Cleve Carney

FRAME: *One out of every eight women will develop breast cancer in her lifetime. 25% of white American women with breast cancer will not live more than 5 years and 40% of black women.*

SPACER: *A friend gave me a small pin that said expect miracles. Does this mean a miracle of health is to be expected? The miracle will be the experience of letting go, of moving beyond the fear of pain and death, the end of life.*

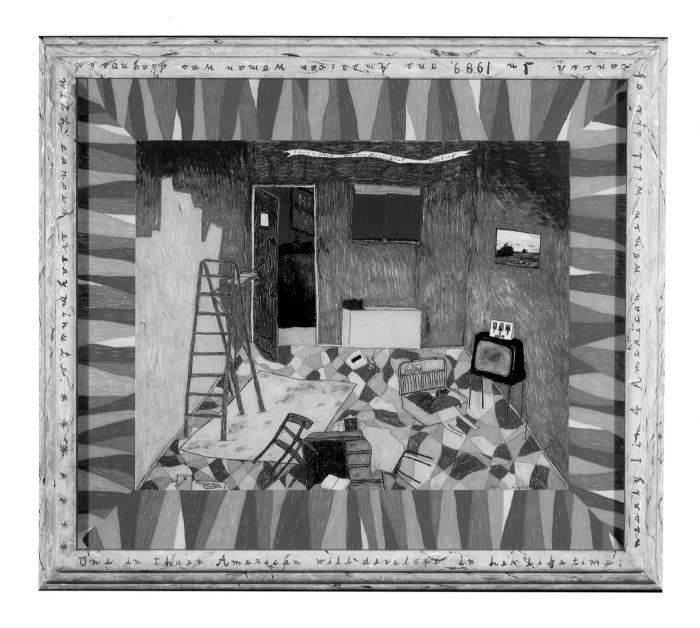

15 THAT'S WHAT WE ARE HERE; JUST VISITING

1993, oil pastel on paper, 29″ × 34″ with painted frame

Collection of Nina and Bill Heiser

FRAME: *One in three American [women] will develope [cancer] in her lifetime. Nearly 1 in 4 American women will die of cancer. In 1989, one American woman was diagnosed with cancer every minute.*

SPACER: *Would anyone in their right mind think of fastidiously redecorating their hotel room every time they booked into one? Audre Lorde thanked God for giving her a temporary time after her diagnosis of breast cancer then she realized that we are all here temporarily.*

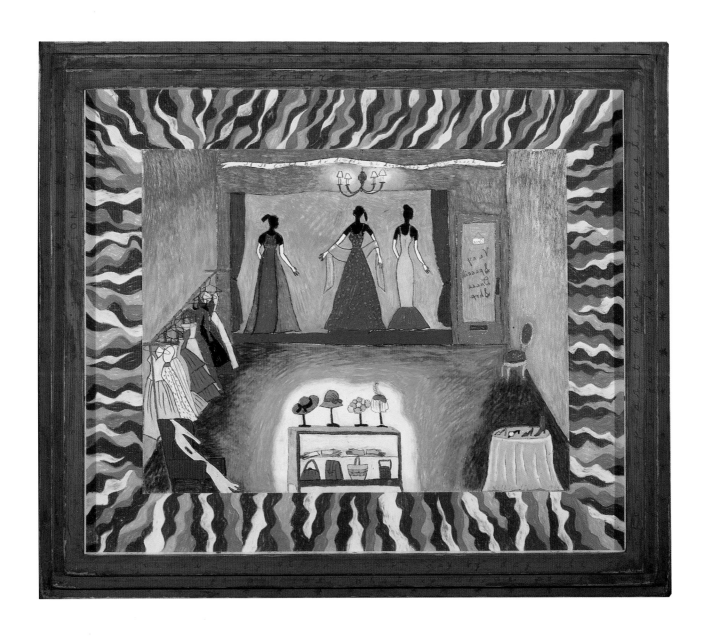

16 IF IT COULD BE AS SIMPLE AS ACQUIRING A NEW FROCK
1993, oil pastel on paper, 29½″ × 34½″ with painted frame
Collection of Robert Fulk

FRAME: *"Surrounded by other women day by day, all of whom appear to have two breasts, it is very difficult sometimes to remember that I AM NOT ALONE. Yet once I face death as a life process, what is there possibly left for me to fear? Who can ever really have power over me again?" Audre Lorde*

SPACER: *She felt the gravity of her body. It was pulling her down. If only the body could function like the latest model Buick. When the fuel pump stopped pumping, you took the car to the service station and replaced the pump. She wished she could do this with her body.*

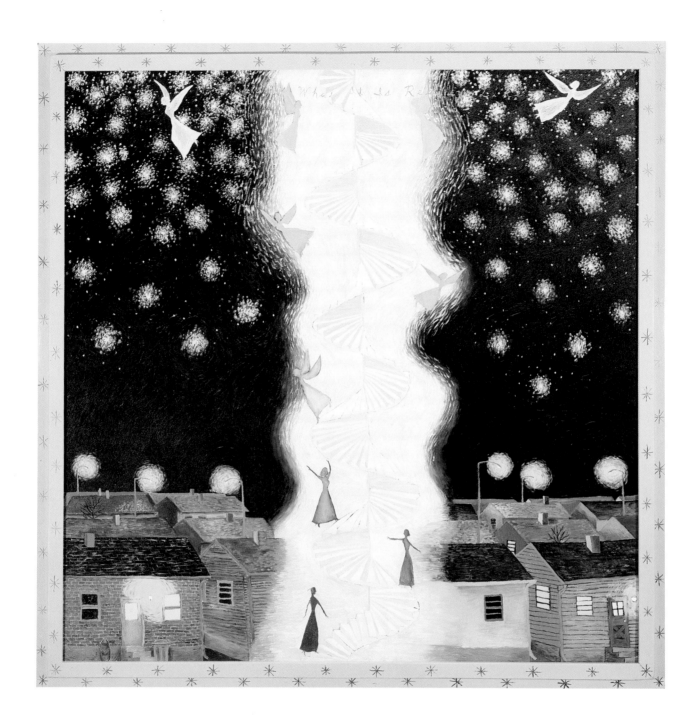

17 TO KISS THE SPIRITS: NOW THIS IS
WHAT IT IS REALLY LIKE

1993, oil on canvas, 66″ × 66″ with painted
frame

National Museum of Women in the Arts,
Washington, D.C., gift of Steven Scott,
Baltimore, in honor of the artist

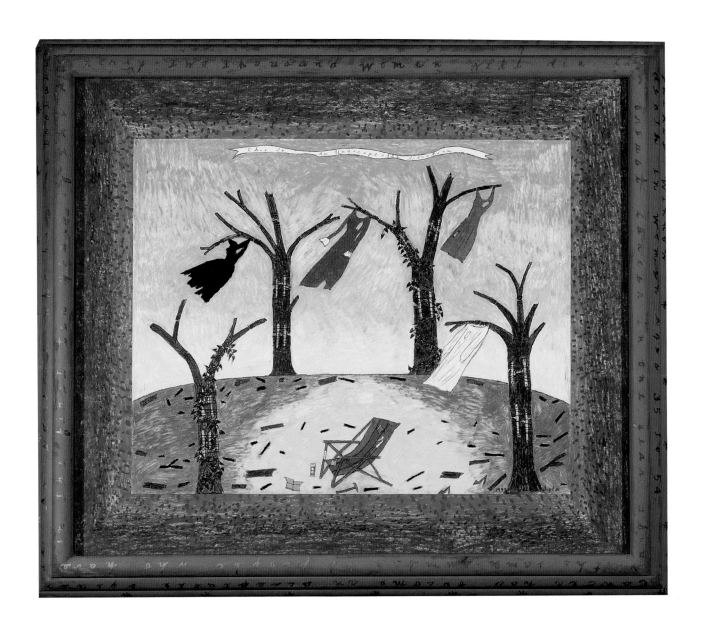

18 THIS IS AN UNACCEPTABLE
SITUATION

1993, oil pastel on paper, 29″ × 33½″ with
painted frame

Collection of Patti and Steve Vile

FRAME: *Forty-two thousand women will die
from breast cancer in one year, about the same
number of people who have in the first ten
years of the AIDS epidemic. Cancer is the
leading cause of death in women ages 35 to
54. Cancer has become an acceptable epidemic.
As someone who has metastatic breast cancer,
that is unacceptable to me. Jackie Winnow*

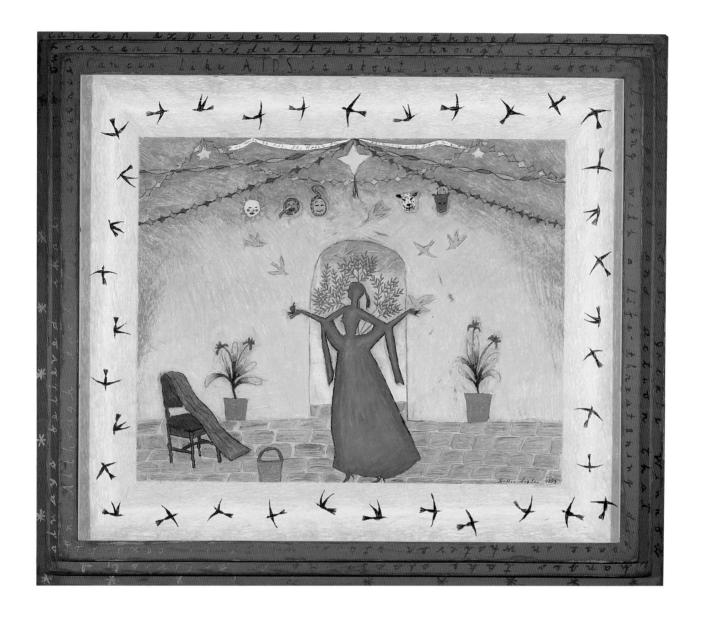

19 IN SPITE OF ALL, SHE RISES IN THE
MORNING WITH JOY IN HER HEART

1993, oil pastel on paper, 29½″ × 34½″
with painted frame

Collection of Margaret Johnson and Ray
Ottenburg

FRAME: *"Cancer, like AIDS, is about living;
it's about living with a life threatening disease,
in whatever stage, whatever condition. Although
each of us experiences cancer individually, it is
through collective support and action that
change takes place. As an activist, I always
believed that, and my own cancer experience
strengthened that belief even more."* Jackie
Winnow

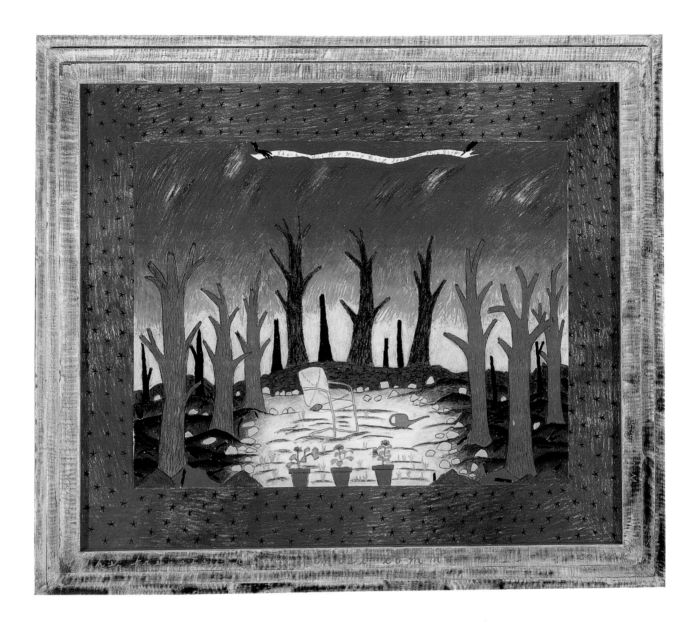

20 THERE ARE NOT MANY REST STOPS ON THIS TRIP

1994, oil pastel on paper, 29½″ × 34½″ with painted frame

Collection of Pat Greer

FRAME: *The breasts are the most common site of cancer in women. Breast cancer is the leading cause of death for women between the ages of 35 and 54. 46,000 women with breast cancer will die this year.*

SPACER: *If she could find a spot in her life where, like a sheet, she could smooth out and straighten up. A place that she could control. It is a spot of peace and calm in her journey. It is comfortable, it is worn and smooth. A spot to sit and rest a spell before moving on.*

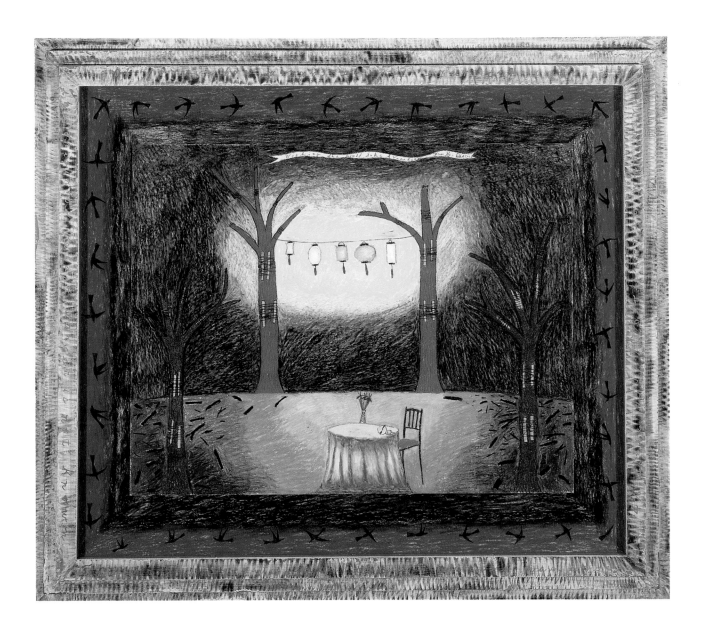

21 WISHING SHE COULD TAKE A
VACATION FROM HER DISEASE
1994, oil pastel on paper, 29½″ × 34½″
with painted frame
Collection of Rose and Fred Roven

FRAME: *The mortality rate from breast cancer has increased 4% since 1950. 70% of women who develop it don't fit into the high-risk groups. The origin of breast cancer is not known.*

SPACER: *When one has a disease like cancer, you can never get away from it. It will never go away. Wherever I go, the cancer comes with me. It is as if I had acquired a new nationality. I am now a citizen of Cancer Country. And only other people with cancer know its language.*

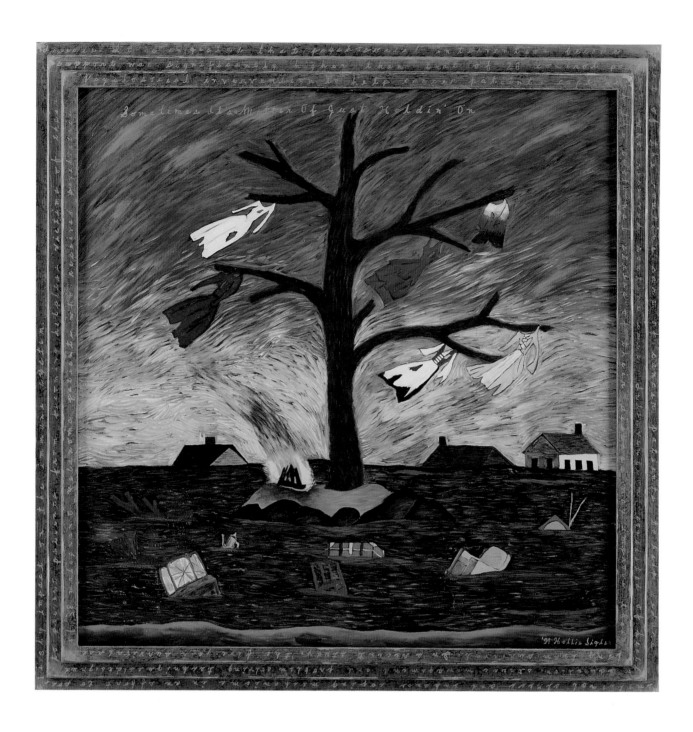

22 SOMETIMES IT'S A MATTER OF JUST HOLDIN' ON

1994, oil on canvas, 42″ × 42″ with painted frame

Collection of Jean Howard

FRAME: *"Psychological intervention to help cancer patients cope with the emotional stress of their disease may improve their long term survival. In a recent study, the five year survival rate of 38 malignant melanoma patients who received psychiatric support was significantly higher than that of 28 control patients who received routine care. Intervention consisted of health education, stress management, and problem solving techniques designed to prevent patients from becoming helpless victims of* *their disease. It is suggested that psychosocial intervention become part of the routine care of cancer patients to help reduce emotional stress and enhance coping mechanisms in an effort to positively impact on the immune system."*

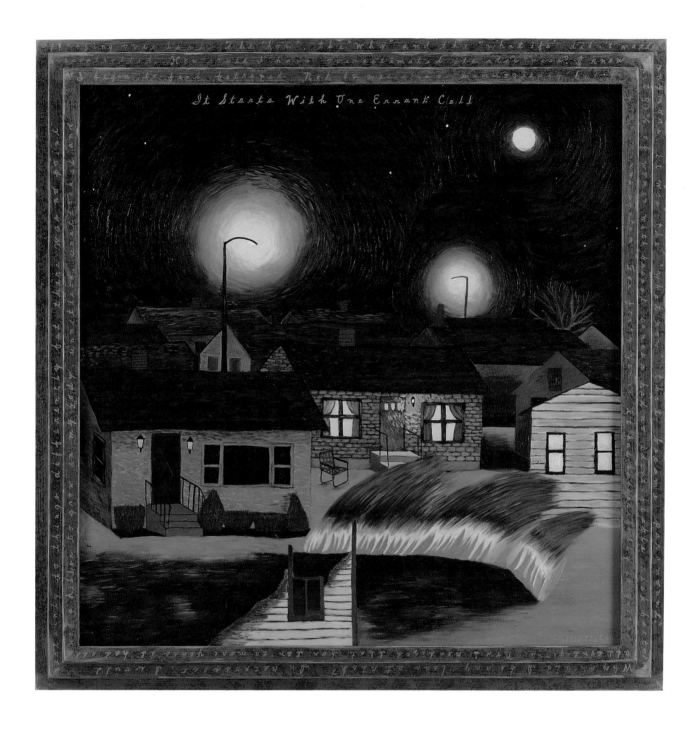

23 IT STARTS WITH ONE ERRANT CELL
1994, oil on canvas, 42″ × 42″ with painted frame
Collection of Jean Howard

FRAME: *"I began to feel betrayed. Not by medicine or mammography but by my own immune system. For forty years, it had successfully conquered all contagions. Now I realized that for ten or more years it had allowed a killer to grow in my body, unnoticed, unattacked and uncontrolled. How could I have overestimated its adeptness? I know that 80% of women with breast cancer had no identifiable risk factors. Why should I be any less at risk? In retrospect, I would certainly do things differently but there was no point agonizing over that. The 'how,' the 'why' and the 'what ifs' didn't matter anymore, it was the 'what now' that became paramount."*

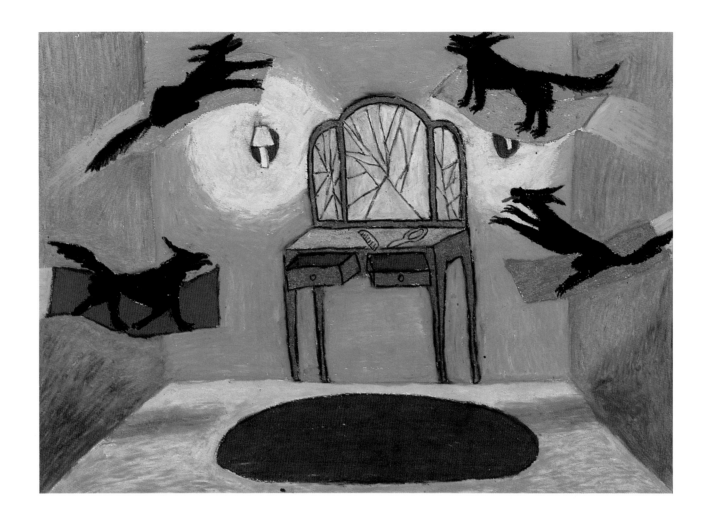

24 ANXIETY RUNS WILD... THERE IS
NOTHING THAT IS INSIGNIFICANT...
THERE ARE NO SIMPLY LITTLE PAINS...
IT DOESN'T REALLY TERRIFY ME... IT
ANGERS ME... I WANT TO LIVE A FULL
LIFE
1994, oil pastel on paper, 15″ × 18″ framed
Collection of Britt Raphling

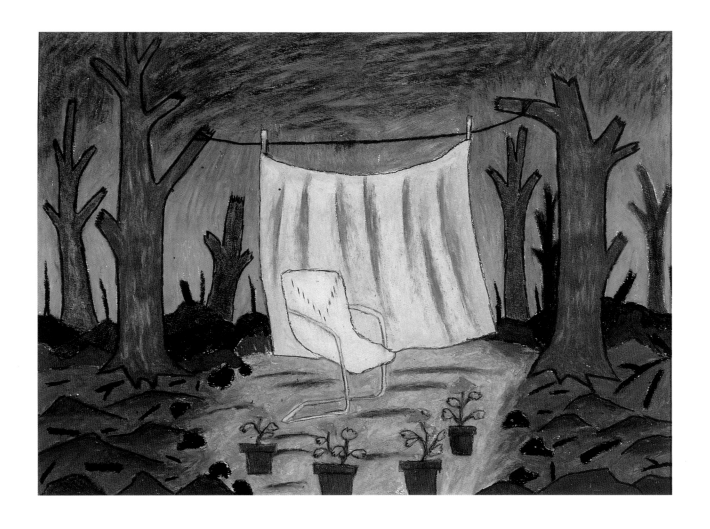

25 EVERY BREAST CANCER PATIENT
WANTS A PLACE WHERE SHE CAN FEEL
SAFE AND SECURE. IT IS A WISH THAT
WILL NOT COME TRUE UNTIL WE FIND
A CURE
1994, oil pastel on paper, 15″ × 18″ framed
Private collection, Baltimore

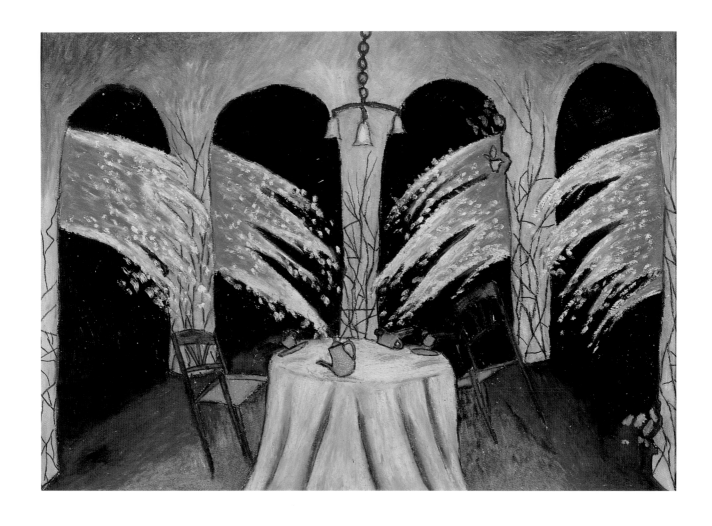

26 BREAST CANCER UNLIKE OTHER
DISEASES SEEMS TO HAPPEN WITHOUT
OUR KNOWLEDGE OF IT BEING THERE.
EVERYTHING SEEMS TO BE FINE. THEN
ONE DAY YOU FIND A LUMP. . . IT IS A
SHOCK
1994, oil pastel on paper, 15″ × 18″ framed
Collection of Britt Raphling

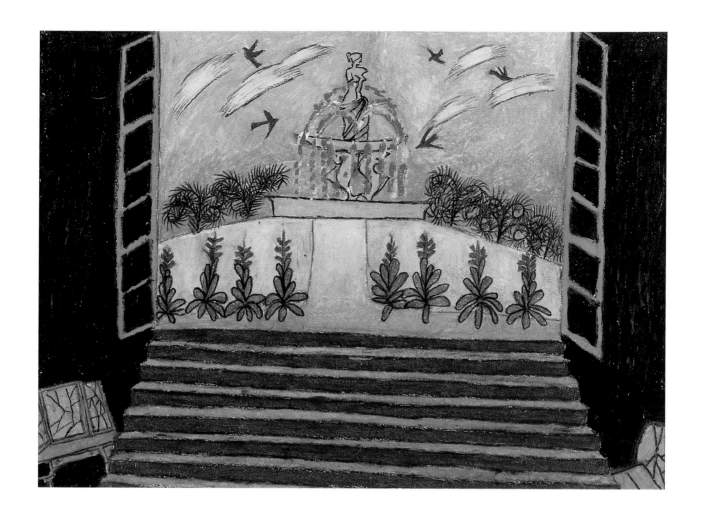

27 I AM NOT SUPPOSED TO EXIST. I
CARRY DEATH AROUND IN MY BODY
LIKE A CONDEMNATION. BUT I DO
LIVE. THE BEE FLIES. THERE MUST BE
SOME WAY TO INTEGRATE DEATH . . .

1994, oil pastel on paper, 15″ × 18″ framed

Courtesy of Carl Hammer Gallery,
Chicago

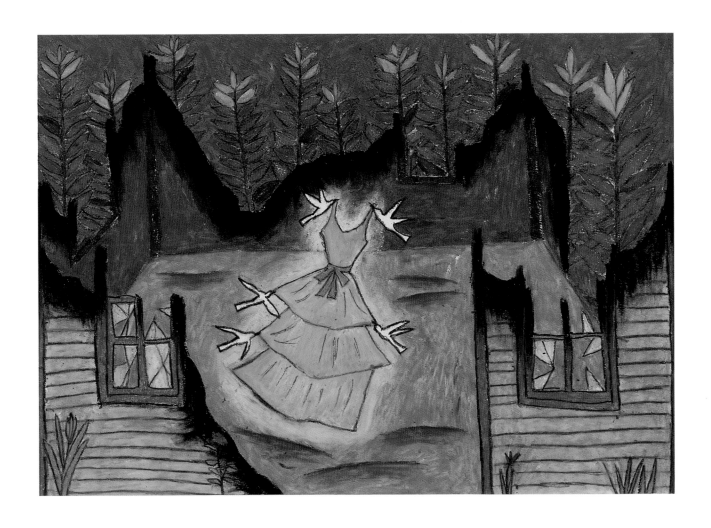

28 A WISH TO TOUCH THE SKY...
CANCER IS A TURNING POINT WHEN
YOU CAN BECOME FREE. IT IS TO
FULFILL A DREAM THAT CAN NO
LONGER WAIT. IT IS TO UNDERSTAND
THE MOMENT
1994, oil pastel on paper, 15″ × 18″ framed
Collection of Hollis Russinoff

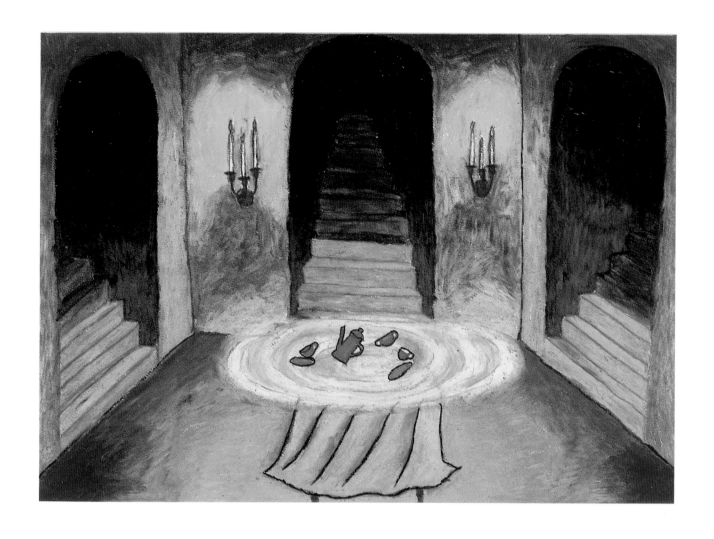

29 NOT TO KNOW WHICH WAY THE
FUTURE WILL LEAD. NONE OF US CAN
KNOW NOR DO WE WISH TO KNOW. I
DON'T WANT A CRYSTAL BALL. FOR
THE FUTURE IS BEYOND MY CONTROL
1994, oil pastel on paper, 15″ × 18″ framed
Collection of Hal Brun

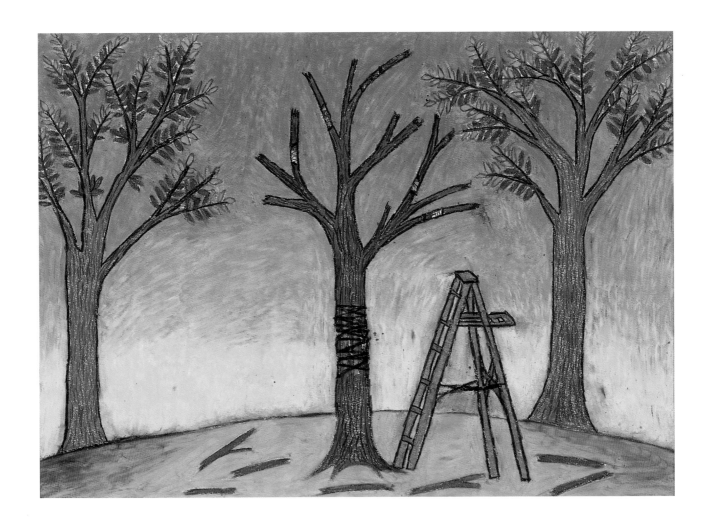

30 THAT MY BREASTS WERE PRECIOUS
TO ME, I KNEW. BUT IT WAS MORE
THAN THAT. I WANTED TO BE WHOLE
AGAIN. I WANTED TO BE THE SAME
AS BEFORE. I DIDN'T WANT TO HAVE
CANCER

1994, oil pastel on paper, 15″ × 18″ framed

Collection of RuthAnn and Michael
Skaggs

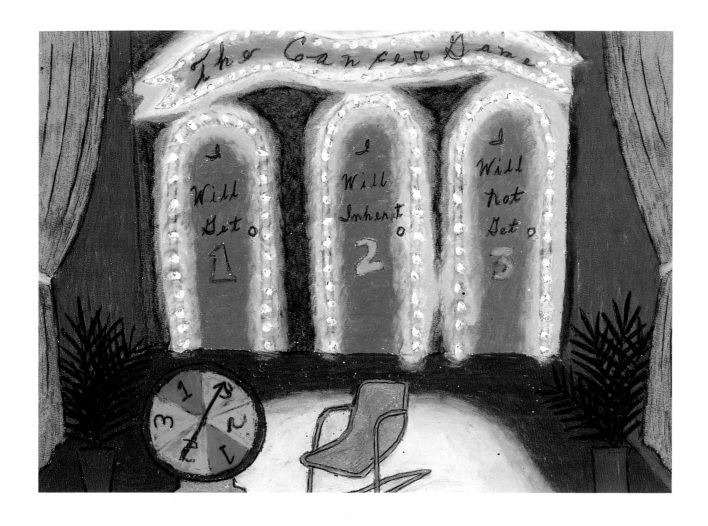

31 WE ARE ALL AT RISK OF HAVING
CANCER. WE DON'T KNOW THE CAUSE
OF BREAST CANCER SO THEREFORE WE
DON'T KNOW THE CURE. EVERY
WOMAN IS FACING A KILLER HIDDEN
IN HER

1994, oil pastel on paper, 15″ × 18″ framed

Collection of RuthAnn and Michael
Skaggs

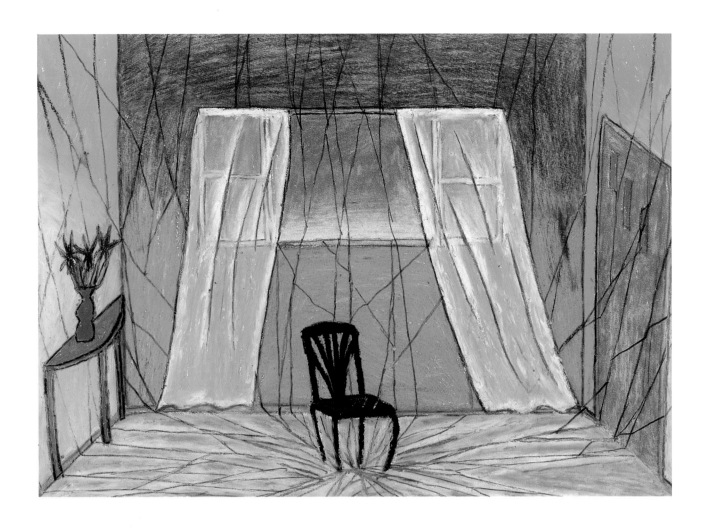

32 SHE WAS DEVASTATED WHEN
THE DOCTOR TOLD HER IT WAS
MALIGNANT. HER LIFE WAS CHANGED
FOREVER. SHE WOULD NEVER BE
ABLE TO RETRIEVE THAT LIFE BEFORE
CANCER
1994, oil pastel on paper, 15″ × 18″ framed
Collection of Dr. and Mrs. Ed Shafranske

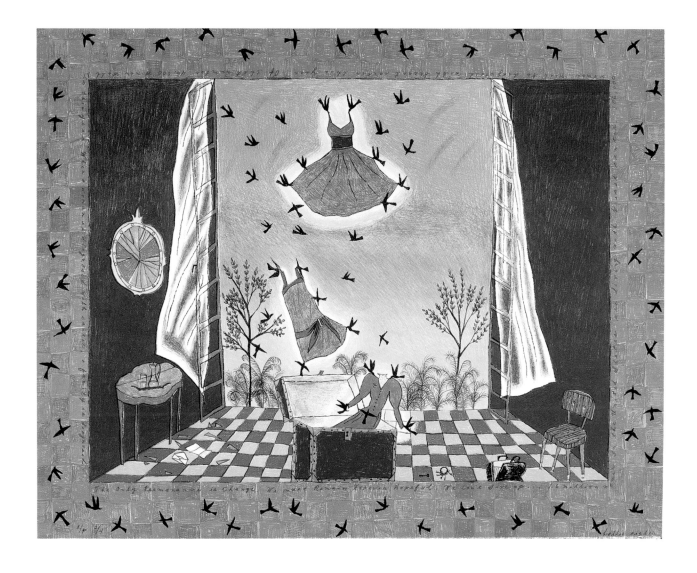

33 THE ONLY PERMANENCE IS CHANGE
1995, color lithograph, 23″ × 29″

AROUND IMAGE: *The only permanence is change. We must remain forever hopeful. We can't give up . . . 1.6 million women in the United States are living with breast cancer. 186,000 women will be diagnosed with breast cancer this year. Of that number 46,000 women will die this year. When a woman is diagnosed with cancer, a family is diagnosed.*

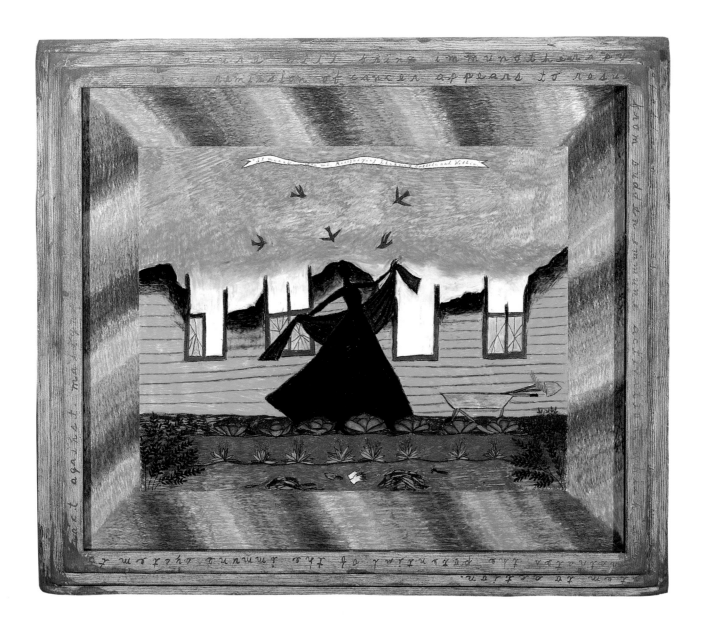

34 IT MEANS, FOR ME, RECOGNIZING
THE ENEMY OUTSIDE AND WITHIN

1995, oil pastel on paper, 29½″ × 34½″
with painted frame

Collection of Ann Whipple

FRAME: *"Spontaneous remission of cancer
appears to result from sudden immune activa-
tion, which demonstrates the potential of the
immune system to react against malignant
growth. The hopes for a cure will bring
immunotherapy capable of rousing a slumber-
ing immune system to action."*

SPACER: *"I have found that battling despair
does not mean closing my eyes to the enormity
of the task of effecting change . . . nor ignoring
the strength and the barbarity of the forces
aligned against us. It means teaching, surviving
and fighting with the most important resource
I have, myself."*

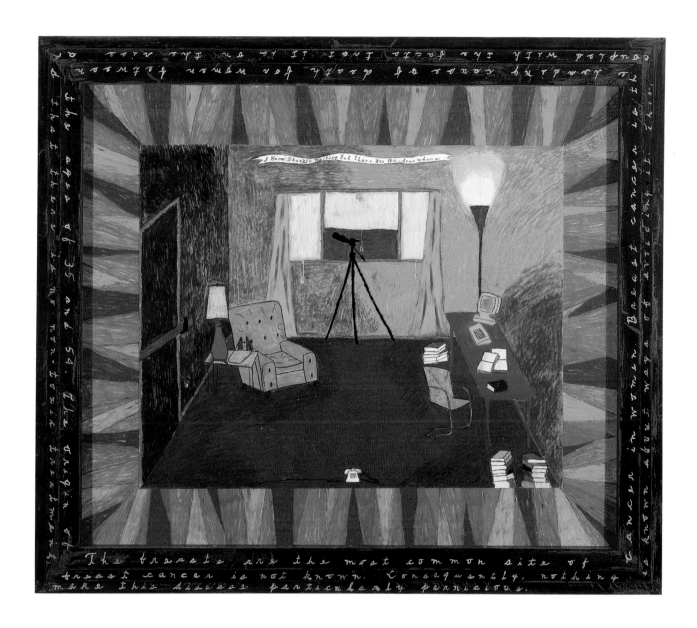

35 I KNOW THAT IT IS WAITING OUT THERE FOR ME . . . SOMEWHERE

1995, oil pastel on paper, 29½″ × 34½″ with painted frame

Courtesy of Carl Hammer Gallery, Chicago

FRAME: *The breasts are the most common site of cancer in women. Breast cancer is the leading cause of death for women between the ages of 35 and 54. The origin of breast cancer is not known. Consequently, nothing is known about ways of avoiding it. This, coupled with the facts that it is on the rise and that there is no non-toxic treatment, makes this disease particularly pernicious.*

SPACER: *I had a dream in which a killer was out there stabbing me. When I went to the police, they said there was nothing they could do to help me. I panicked as I realized I had no one who could protect me from my killer.*

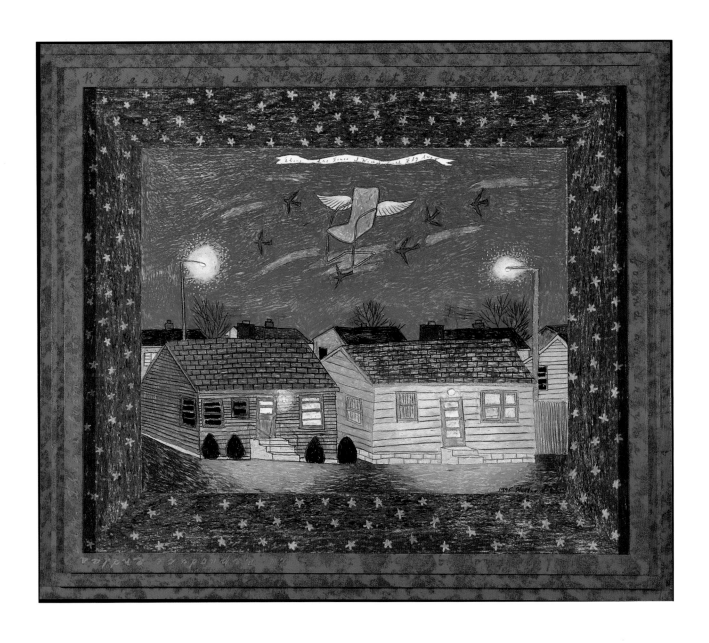

36 THERE ARE TIMES I WISH I COULD
FLY AWAY

1995, oil pastel on paper, 29¼″ × 34¼″
with painted frame

Collection of Joan and Henry Arenberg

FRAME: *Researchers at McMaster University
in Ontario have found an enzyme in cancer
cells that allows them to reproduce endlessly.
This information could help find a cure.*

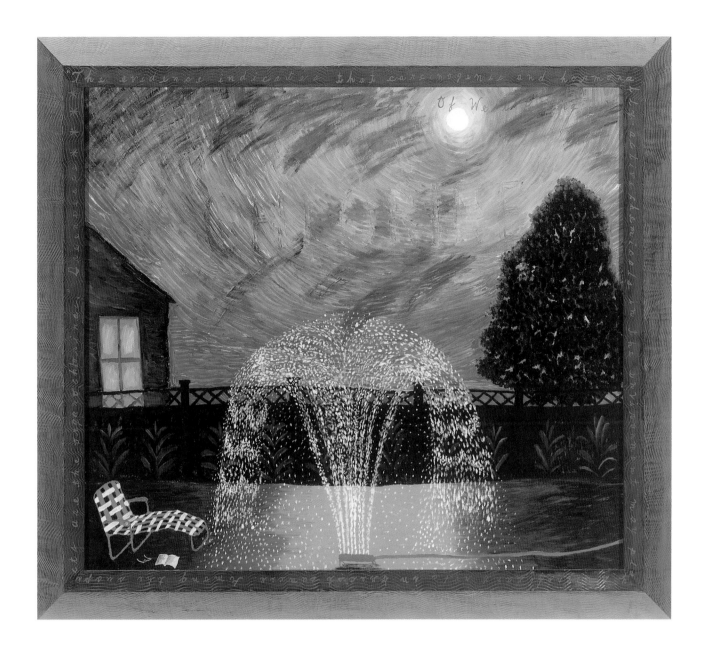

37 I ALWAYS HAD A FEELING OF WELL
BEING

1995, oil on canvas, 32″ × 36″ with painted
frame

Collection of Laura and Keith Tucker

FRAME: *"The evidence indicates the carcino-*
genic and hormonally active chemicals in the
environment may play a significant role in
breast cancer. Among the suspects are the
organochlorines." Greenpeace

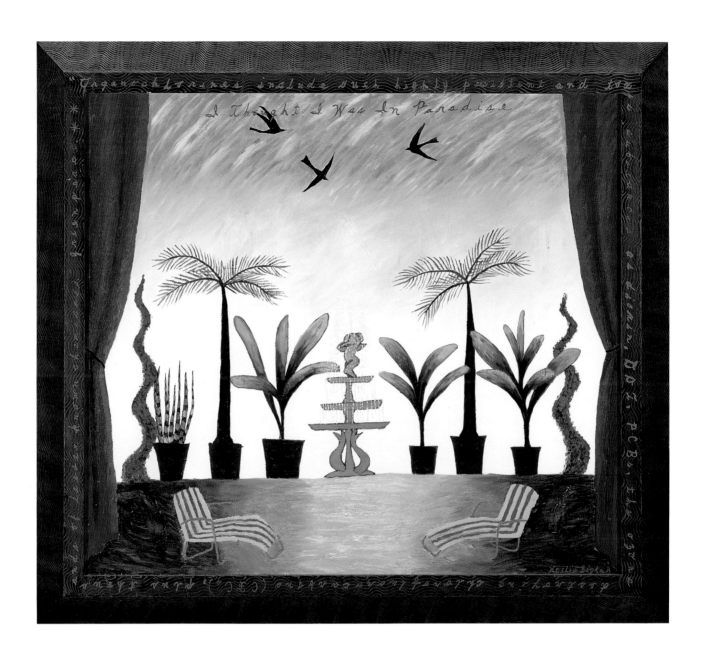

38 I THOUGHT I WAS IN PARADISE
1995, oil on canvas, 32″ × 36″ with painted frame
Madison Art Center, Wisconsin

FRAME: *"Organochlorines include such highly persistent and toxic substances as dioxin, DDT, PCBs, the ozone destroying chloro-fluorocarbons (CTC), plus thousands of lesser known chemicals."* Greenpeace

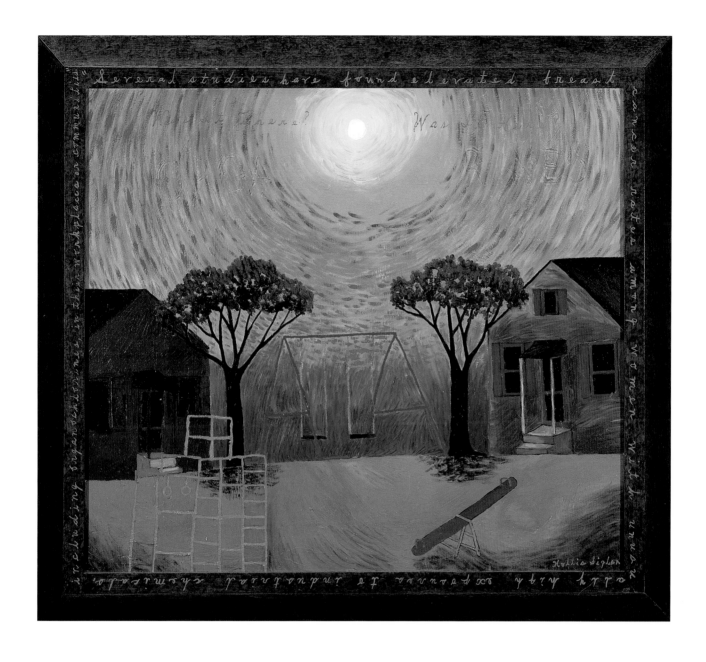

39 WAS IT THERE? WAS IT HERE?
1995, oil on canvas, 32″ × 36″ with painted
frame
Collection of Chet and Nancy Kamin

FRAME: *"Several studies have found elevated
breast cancer rates among women with unusu-
ally high exposure to industrial chemicals,
including organochlorines in their workplaces
or communities."*

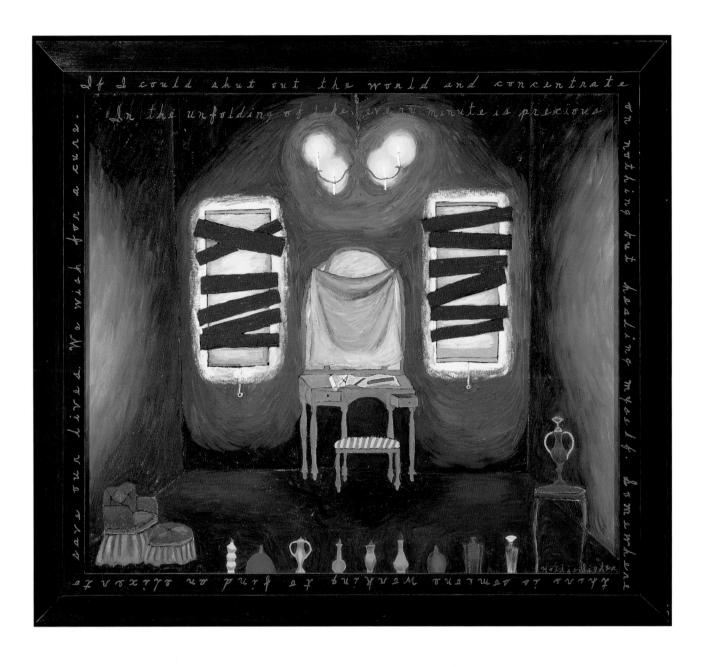

40 IN THE UNFOLDING OF LIFE, EVERY MINUTE IS PRECIOUS

1995, oil on canvas, 32″ × 36″ with painted frame

Private collection, Baltimore

FRAME: *If I could shut out the world and concentrate on nothing but healing myself. Somewhere there is someone working to find an elixir to save our lives. We wish for a cure.*

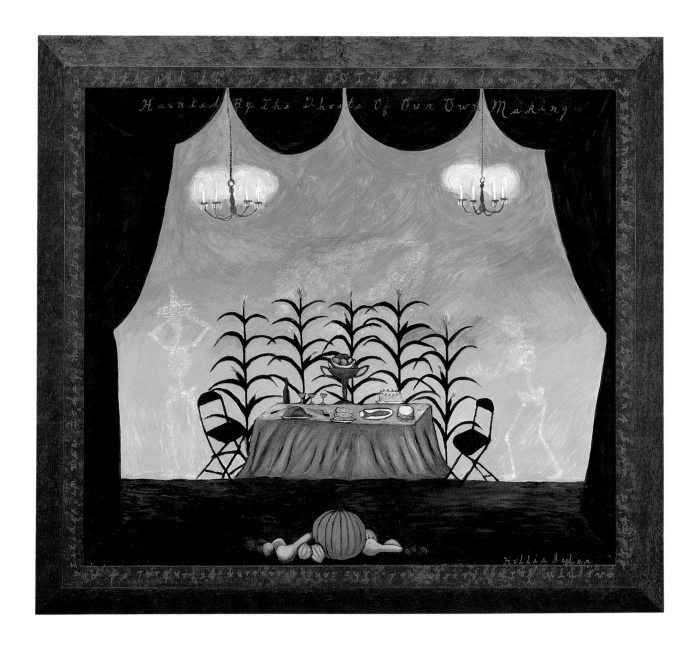

41 HAUNTED BY THE GHOSTS OF OUR OWN MAKING

1995, oil on canvas, 32″ × 36″ with painted frame

Spencer Museum of Art, University of Kansas, Lawrence

FRAME: *"Although the use of DDT has been banned by the government for years, its long term effects are now being recognized. The cancer causing potential of pesticides in use today may be hidden for years to come."*

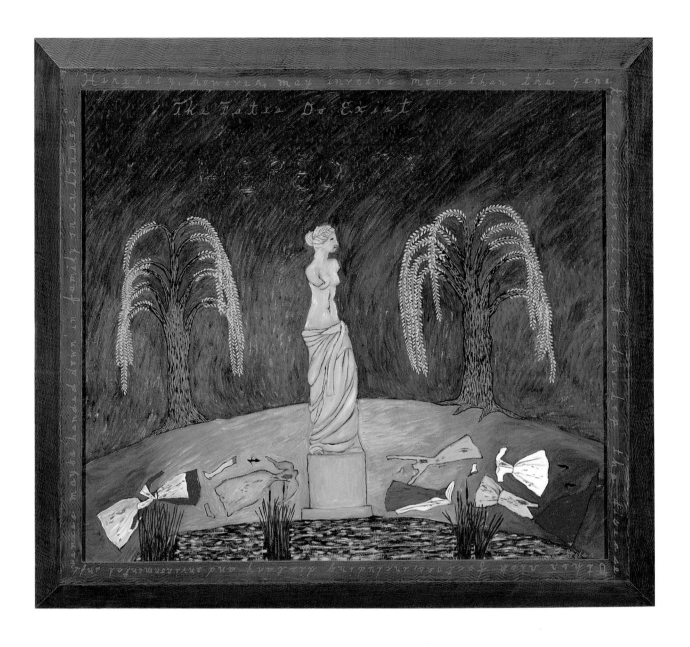

42 THE FATES DO EXIST

1995, oil on canvas, 32″ × 36″ with painted frame

The National Museum of Women in the Arts, Washington, D.C.

FRAME: *"Heredity, however, may involve more than the genetic predisposition to develop the disease. Other risk factors, including dietary and environmental influences may be handed down in families or cultures."*

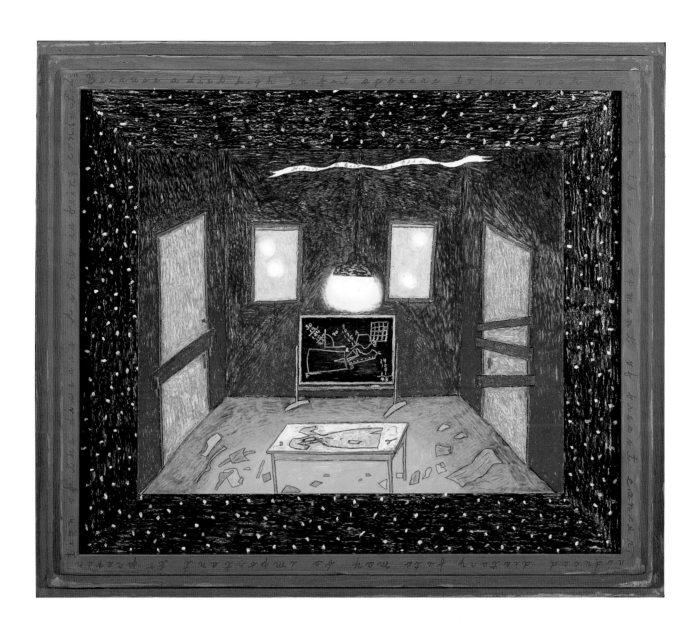

43 HOPING TO BEAT THE ODDS
1995, oil on paper, 29½″ × 34½″ with
painted frame
Collection of Arlene Santoro

FRAME: *"Because a diet high in fat appears to be a risk factor in the development of breast cancer, reduced dietary fats may be important to prevention of the disease." A study is being conducted.*

SPACER: *As someone with cancer, I am always trying to beat the disease. My eyes and ears are open to finding information about this disease. I want to find information that will cure me. But what I seek I will not find without, I'll only find within.*

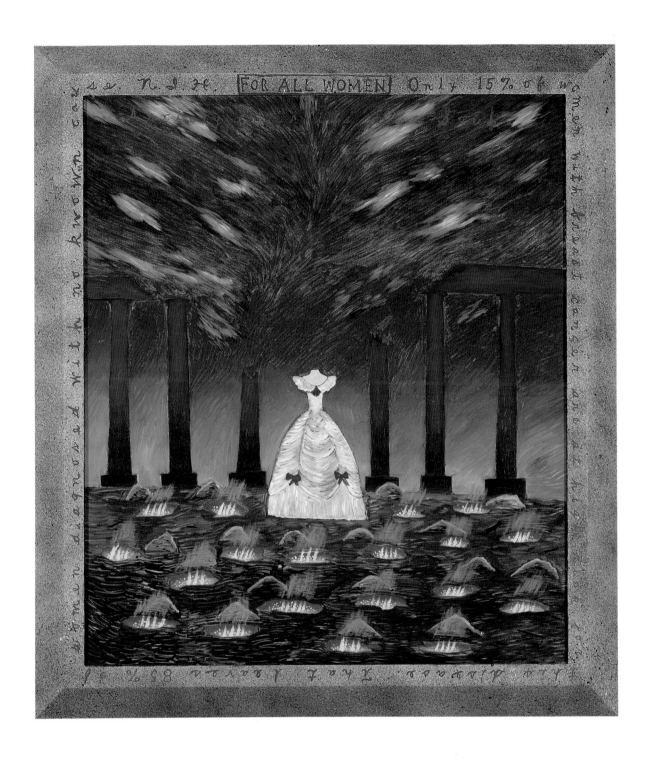

44 ANXIETY ENCIRCLES HER SOUL
1995, oil on canvas, 36″ × 32″ with painted frame
Collection of Anne Lyman

FRAME: *For all women only 15% of women with breast cancer are at high risk for this disease. That leaves 85% of women diagnosed with no known cause. N.I.H.*

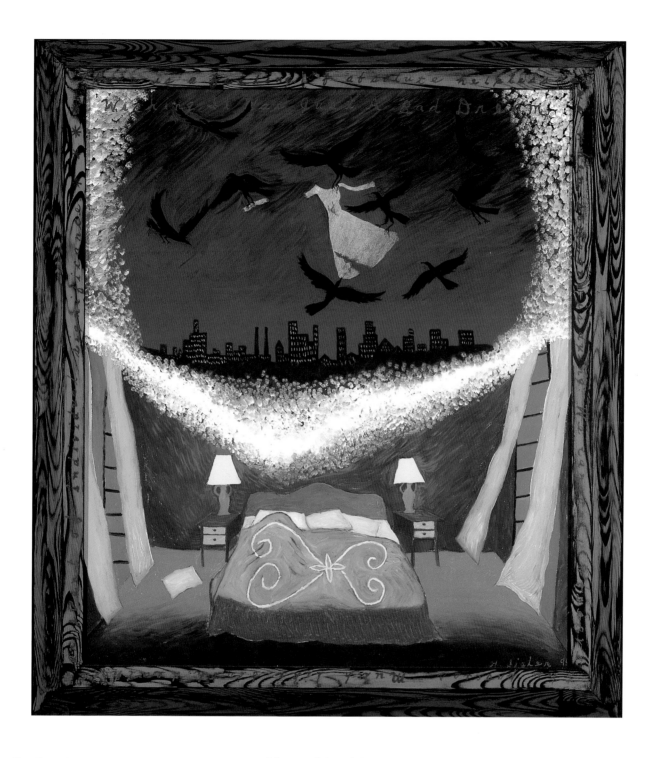

45 WISHING IT WAS JUST A BAD DREAM
1995, oil on canvas, 36″ × 32″ with painted frame
Collection of Jean Howard

FRAME: *There is a feeling of absolute helplessness when someone is dying. We can only observe the process. Much like birth, death is an event of individual significance.*

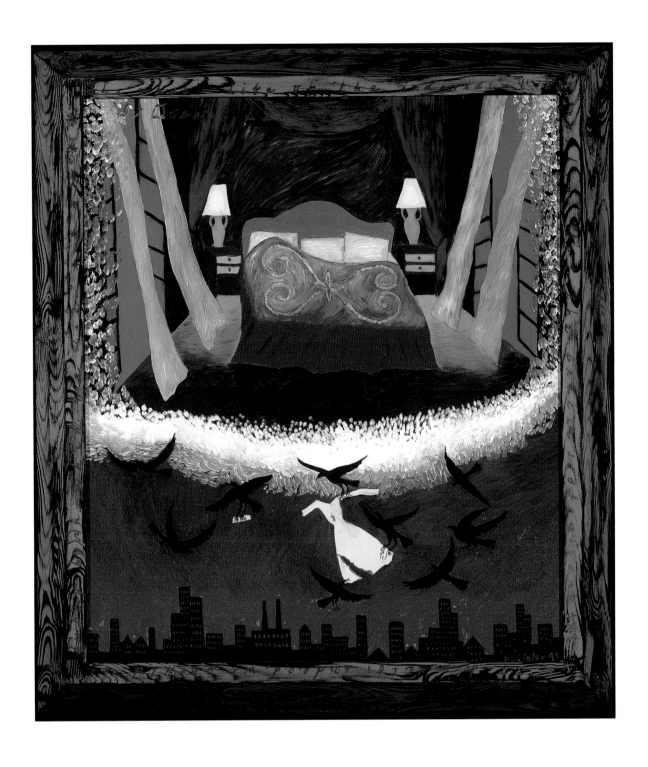

46 IT DOESN'T SEEM REAL
1995, oil on canvas, 36″ × 32″ with painted
frame
Collection of Jean Howard

FRAME: *"The whole life of the individual
is nothing but the process of giving birth to
himself; indeed, we should be fully born when
we die."*

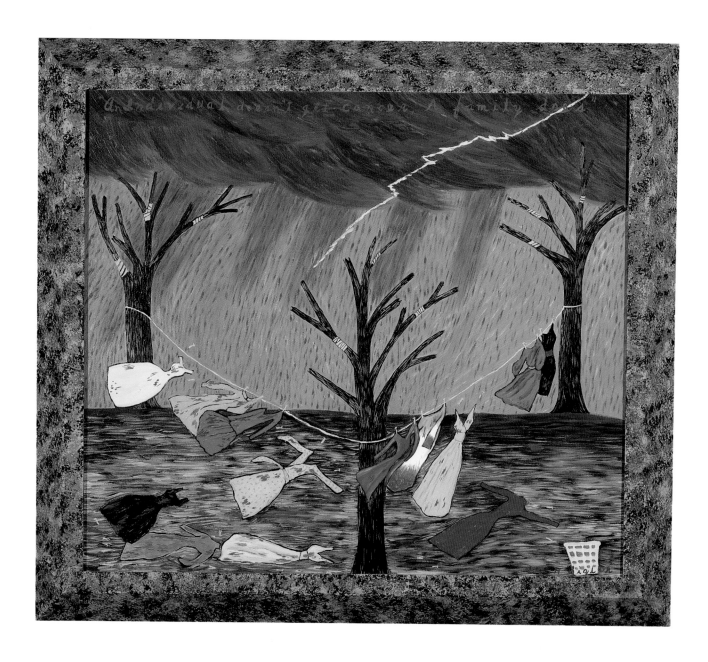

47 AN INDIVIDUAL DOESN'T GET
CANCER. A FAMILY DOES

1995, oil on canvas, 32″ × 36″ with painted
frame

Fort Wayne Museum of Art, Indiana, given
by the Journal Gazette Foundation, Inc.,
the Gamma Lambda Chapter of Kappa
Kappa Kappa, Colleen Benninghoff,
General Electric Company, and the
community in honor and memory of
women in northeast Indiana who have
fought against breast cancer

FRAME: *A study conducted by the New York
State Health Department found that women
who once lived near large chemical plants had
a 60% higher chance of breast cancer in later
life.*

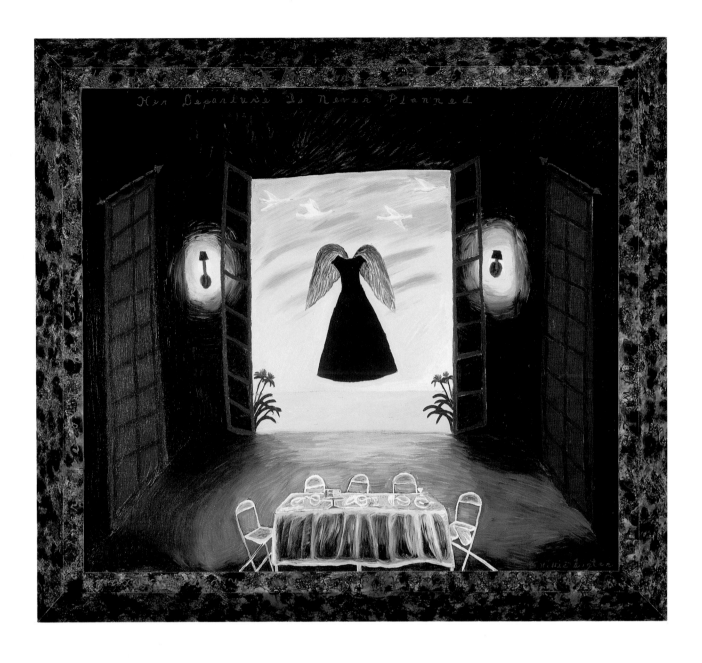

48 HER DEPARTURE IS NEVER PLANNED
1995, oil on canvas, 32″ × 36″ with painted frame
Collection of Sandy Guettler

FRAME: *The rate of death from breast cancer for white women declined 5.5 percent between 1989 to 1992. However, African-American women experienced an increase of 2.6 percent in that time.*

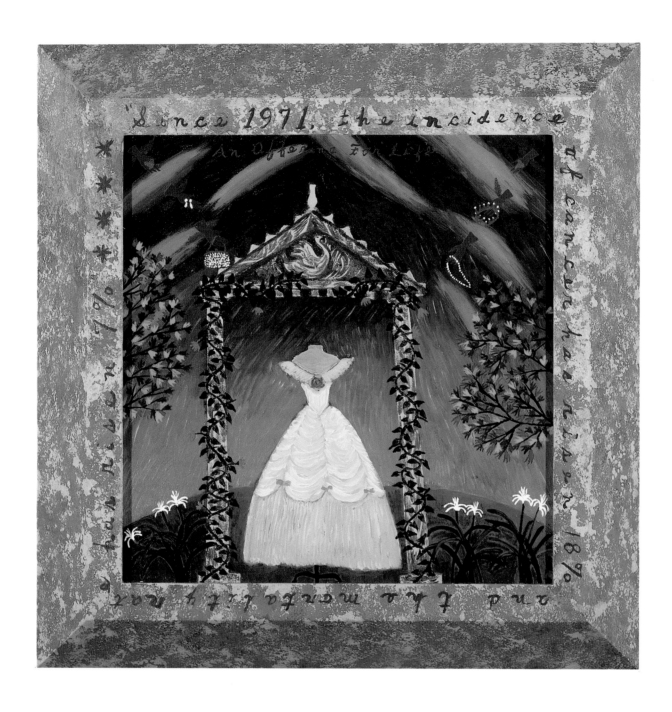

49 AN OFFERING FOR LIFE

1995, oil on canvas, 19¾″ × 19¾″ with painted frame

Collection of Linda Lee Alter

FRAME: *"Since 1971, the incidence of cancer has risen 18% and the mortality rate has risen 7%."*

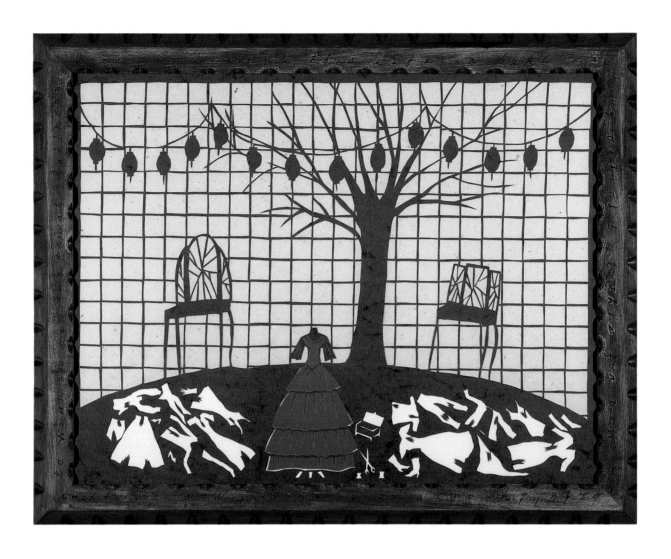

50 SOME SAY LEAVING THIS LIFE IS LIKE
CASTING OFF OLD CLOTHES

1996, cut paper, 22¾″ × 28¾″ with painted
frame

Collection of Maureen Gustafson and John
Rosenbloom

FRAME: *Some say leaving this life is like*
casting off old clothes for new. Hopefully, she
has an elegant new evening gown to wear in
her own private ballroom.

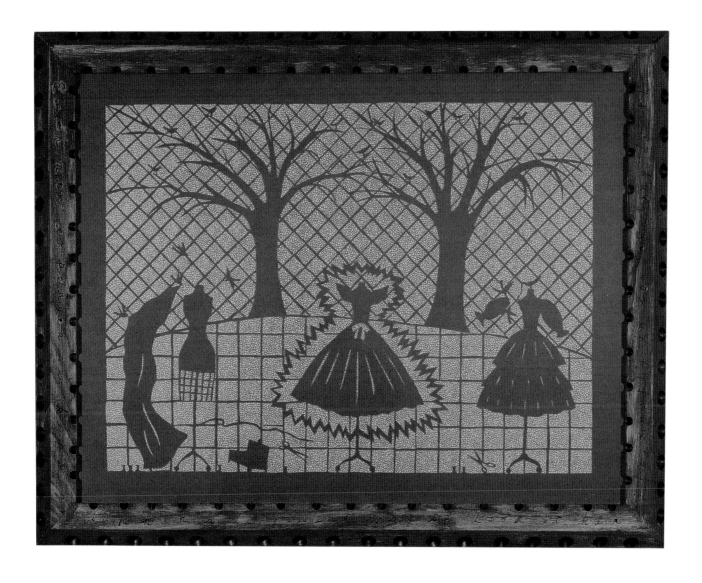

51 IS IT POSSIBLE TO FEEL BRAND NEW?
1996, cut paper, 22¾″ × 28¾″ with painted
frame
Collection of Cynthia Raskin

FRAME: *Is it possible to feel brand new? Each
new experience kept giving her a different way
to look at her life, mostly in confronting death.*

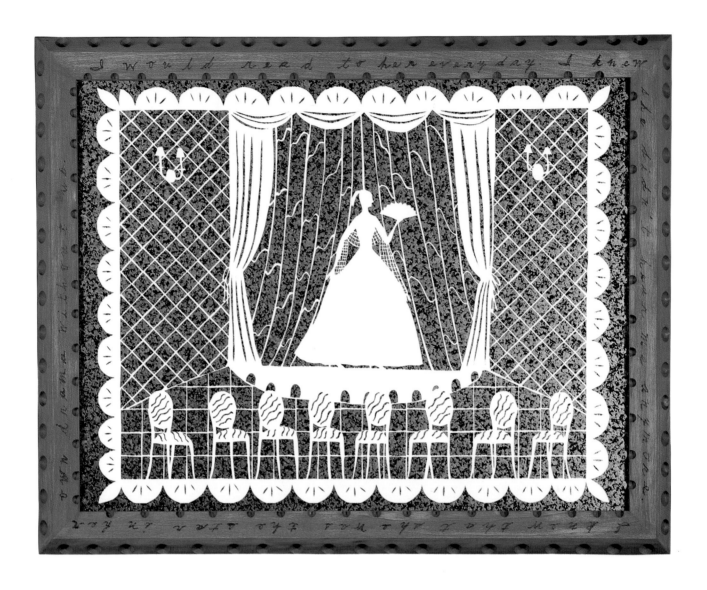

52 I WOULD READ TO HER EVERY DAY
1996, cut paper, 22¾″ × 28¾″ with painted frame
Spencer Museum of Art, University of Kansas, Lawrence

FRAME: *I would read to her every day. I knew she didn't hear me anymore. I knew that she was the star in her own drama without us.*

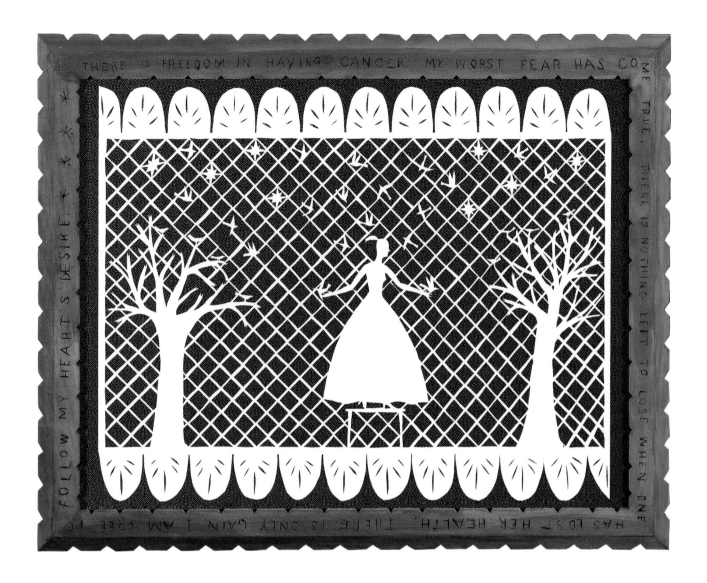

53 THERE IS FREEDOM IN HAVING
CANCER
1996, cut paper, 22¾" × 28¾" with painted
frame
Collection of Marilyn Sward

FRAME: *There is freedom in having cancer.*
My worst fear has come true. There is nothing
left to lose when one has lost her health. There
is only gain. I am free to follow my heart's
desire.

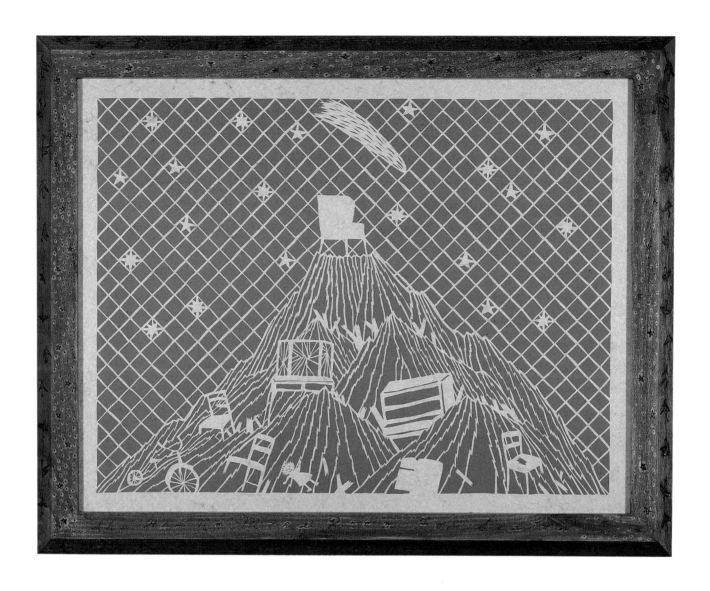

54 SHE HAS NO MORE ROOM FOR SORROW

1996, cut paper, 22¾″ × 28¾″ with painted frame

Collection of Jonathan Kamholtz

FRAME: *She has no more room for sorrow.*

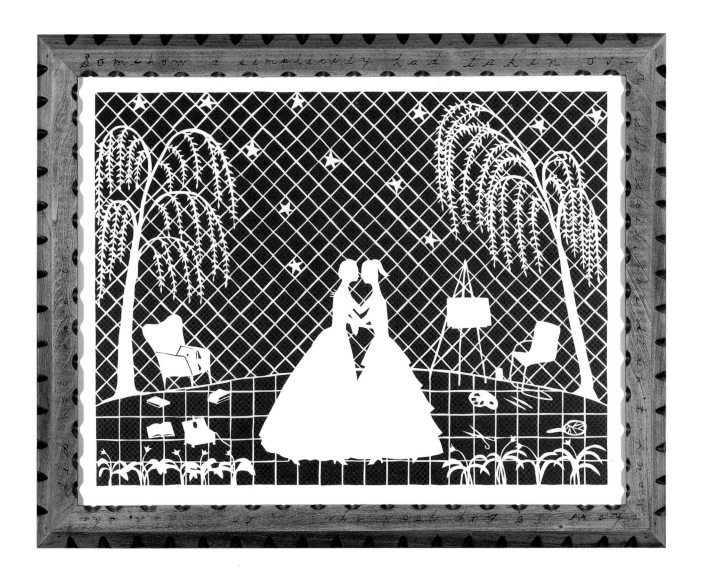

55 SOMEHOW A SIMPLICITY HAD
TAKEN OVER
1996, cut paper, 22¾″ × 28¾″ with painted
frame
Collection of Nina and Bill Heiser

FRAME: *Somehow a simplicity had taken
over. She said, she didn't know how to say
goodbye . . . I told her, she did not have to.*

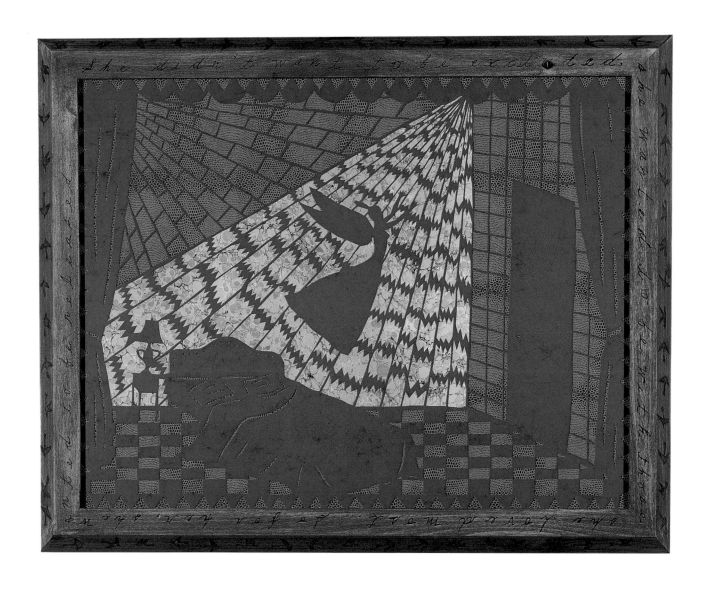

56 SHE DIDN'T WANT TO BE EXCLUDED
1996, cut paper, 22¾″ × 28¾″ with painted frame
Collection of Fay Clayton

FRAME: *She didn't want to be excluded. She wanted to be with those she loved most. So for her, she wanted to be released.*

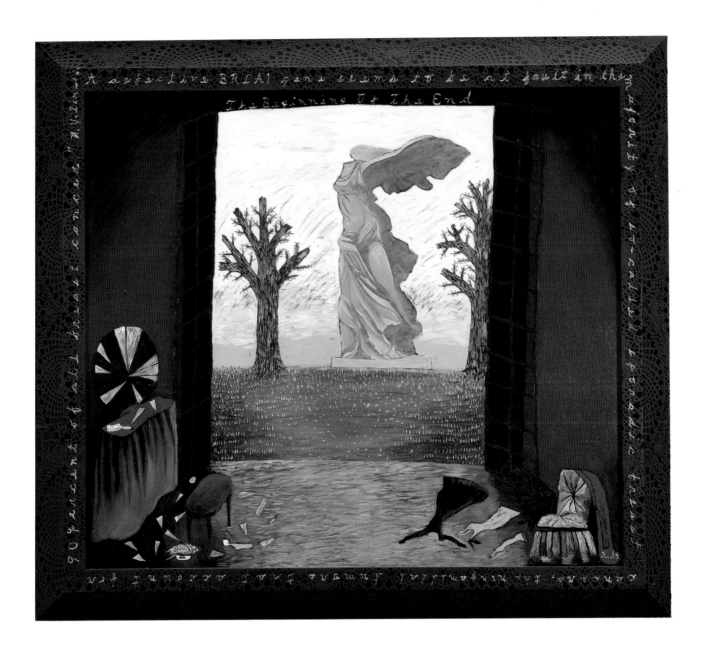

57 THE BEGINNING OF THE END

1996, oil on canvas, 32″ × 36″ with painted frame

Courtesy of Steven Scott Gallery, Baltimore

FRAME: *"A defective BRCA1 gene seems to be at fault in the majority of so-called sporadic breast cancers, the nonfamilial tumors that account for 90 percent of all breast cancer."*
New York Times

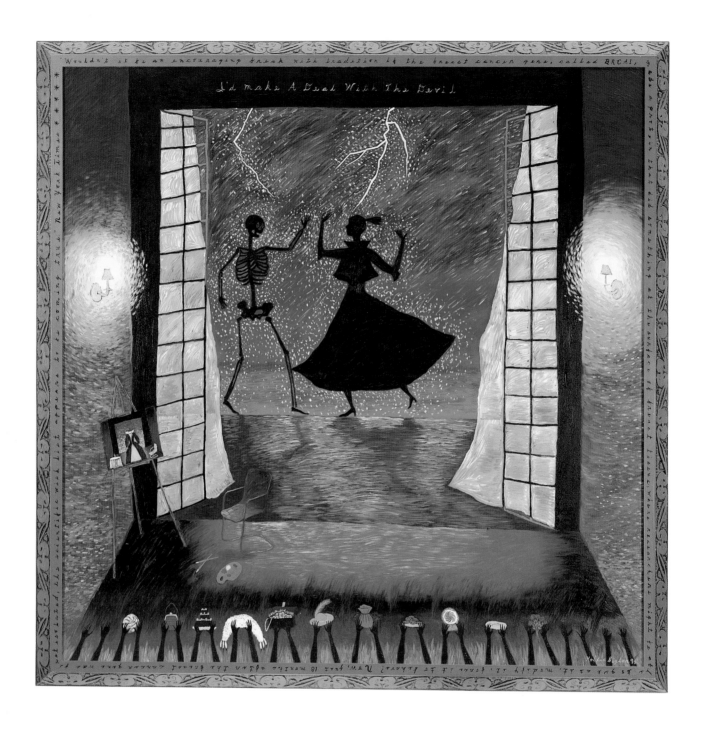

58 I'D MAKE A DEAL WITH THE DEVIL
1996, oil on canvas, 66″ × 66″ with painted
and carved frame
Private collection, Baltimore

FRAME: *"Wouldn't it be an encouraging break
with tradition if the breast cancer gene, called
BRCA1, made a protein that did something
at the surface of breast tissue, where researchers
might be able to get at it, modify it, force it
to behave? Now, just 18 months after the
breast cancer gene was first isolated, the scien-
tific wish list appears to be coming true."*
New York Times

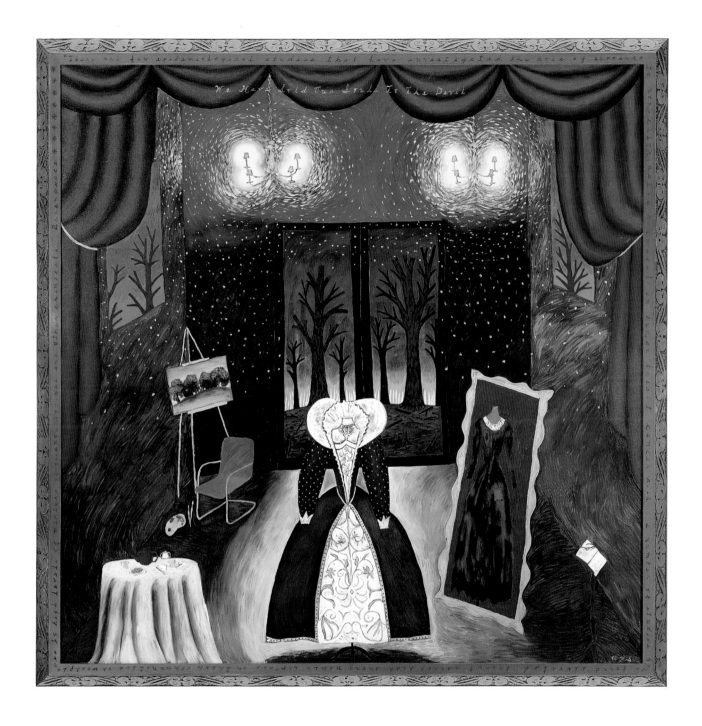

59 WE HAVE SOLD OUR SOULS TO THE
DEVIL

1996, oil on canvas, 66″ × 66″ with painted
and carved frame

Courtesy of Carl Hammer Gallery,
Chicago

FRAME: *"There are few epidemiological studies
that have investigated the role of exposure to
non-chlorinated chemicals in human breast
cancer risk . . . a number of studies have found
elevated breast cancer risk among women
exposed in their communities or workplaces
to high levels of mixture of organochlorines
and other chemicals." Greenpeace*

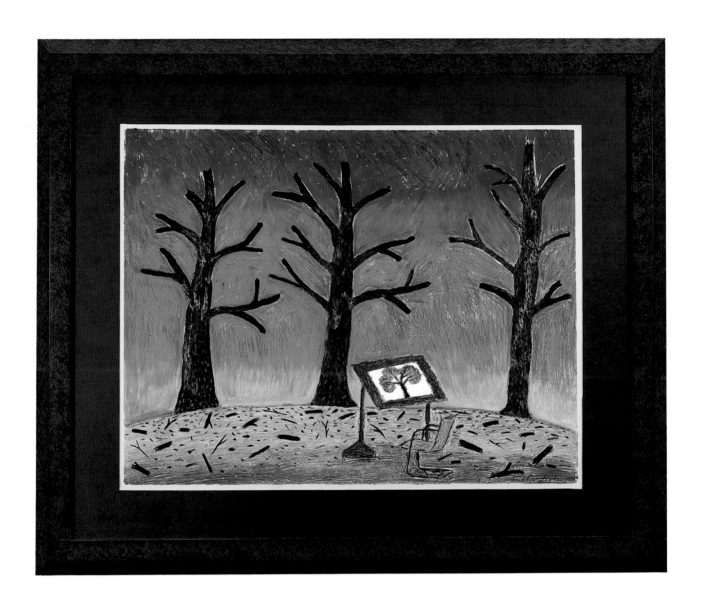

60 IS THIS WISHFUL THINKING? MAYBE
NOT
1996, monoprint, 27½″ × 33½″ with
painted frame
Private collection, Cincinnati

REFERENCES

1 SPACER: Audre Lorde, *The Cancer Journals* (San Francisco: Spinsters Ink, 1980), p. 62.

2 SPACER: American Cancer Society.

3 SPACER: Lorde, *Cancer Journals,* p. 10.

5 FRAME: Lorde, *Cancer Journals,* p. 9; SPACER: American Cancer Society.

6 SPACER: American Cancer Society.

7 SPACER: O. Carl Simonton, M.D., Stephanie Matthews-Simonton, and James L. Creighton, *Getting Well Again* (New York: Bantam Books, 1978), pp. 57, 62.

8 SPACER: American Cancer Society.

9 SPACER: Lorde, *Cancer Journals,* p. 69.

10 FRAME AND SPACER: American Cancer Society.

11 FRAME AND SPACER: Simonton, Matthews-Simonton, and Creighton, *Getting Well Again,* pp. 62–64, 85.

12 SPACER: Lorde, *Cancer Journals,* p. 61.

13 FRAME: *The Encyclopedia Americana* (New York and Chicago: Encyclopedia Americana Corporation, 1918), vol. 5, p. 490.

14 FRAME: American Cancer Society.

15 FRAME: American Cancer Society.

16 FRAME: Lorde, *Cancer Journals,* p. 61.

18 FRAME: Jackie Winnow, "Lesbians Evolving Health Care: Our Lives Depend On It," in *Cancer as a Women's Issue:*

Scratching the Surface (Chicago: Third Side Press, 1991), pp. 23–24.

19 FRAME: Winnow, "Lesbians Evolving Health Care," p. 27.

20 FRAME: Secondary research provided by Information Age Resources, Research and Information Consulting Services, Chicago.

21 FRAME: Secondary research provided by Information Age Resources, Research and Information Consulting Services, Chicago.

22 FRAME: Secondary research provided by Information Age Resources, Research and Information Consulting Services, Chicago.

23 FRAME: Barbara Amsler, "Barbara Amsler," in *Words against the Shifting Seasons: Women Speak of Breast Cancer* (Chicago: Calhoun Press, Columbia College Chicago, 1994), p. 22.

33 TITLE: American Cancer Society; Terry Tempest Williams, *Refuge: An Unnatural History of Family and Place* (New York: Vintage, 1992), p. 214.

34 FRAME: Andrew Weil, M.D., *Spontaneous Healing* (New York, Alfred A. Knopf, 1995), p. 269; SPACER: Lorde, *Cancer Journals,* p. 17.

35 FRAME: Secondary research provided by Information Age Resources, Research and Information Consulting Services, Chicago.

36 FRAME: *Wall Street Journal,* April 12, 1994.

37 FRAME: Joe Thorton, *Chlorine, Human Health, and the Enviornment: The Breast Cancer Warning* (Washington, D.C.: Greenpeace, 1993), p. 9.

38 FRAME: Thorton, *Chlorine, Human Health, and the Enviornment,* p. 9.

39 FRAME: Thorton, *Chlorine, Human Health, and the Enviornment,* p. 37.

41 FRAME: M. W. DeGregorio and V. J. Wiebe, *Tamoxifen and Breast Cancer* (New Haven: Yale University Press, 1994), p. 13.

42 FRAME: DeGregorio and Wiebe, *Tamoxifen and Breast Cancer,* p. 11.

43 FRAME: DeGregorio and Wiebe, *Tamoxifen and Breast Cancer,* p. 84.

44 FRAME: National Institutes of Health.

46 FRAME: Tempest Williams, *Refuge,* p. 232, quoting Erich Fromm.

47 FRAME: *New York Times,* April 13, 1994.

48 FRAME: Y-ME Hotline, vol. 51, March/ April 1995.

49 FRAME: *Wall Street Journal,* September 30, 1994.

57 FRAME: *New York Times,* March 5, 1996.

58 FRAME: *New York Times,* March 5, 1996.

59 FRAME: Thorton, *Chlorine, Human Health, and the Enviornment,* p. 37.